The Campus History Series

RANDOLPH-MACON COLLEGE

D1611506

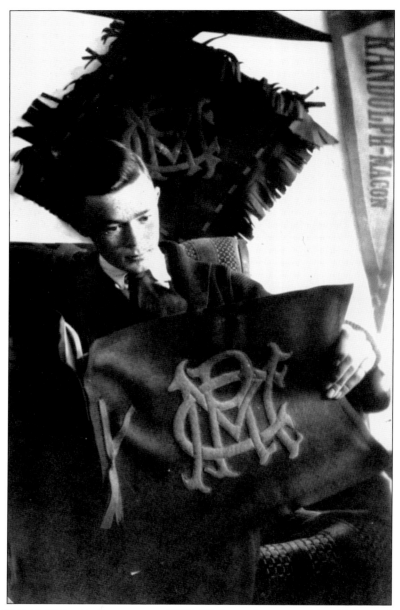

RANDOLPH-MACON COLLEGE SCRAPBOOK, 1915. Without the care with which students pasted photographs and clippings into their scrapbooks, this book would be a poor thing. Thank yous to those who donated treasured scrapbooks to the library, especially the scrapbooks of Shelton Short Jr., class of 1919; Michael Maurice, class of 1924; and Roscoe Johnson, class of 1925.

ON THE COVER: BASEBALL TEAM, 1902. Led by captain H. C. Lipscomb and manager J. C. Copenhaver, the baseball team had a winning season in 1902. Unfortunately, the game with Hampden-Sydney was called at 3-3, when rain ended play at the end of the first half of the fifth inning. As with many of the yearbook photographs, this image was posed on the steps of President Blackwell's house.

The Campus History Series

RANDOLPH-MACON COLLEGE

Virginia E. Young

ARCADIA
PUBLISHING

Published by Arcadia Publishing
Charleston, South Carolina

Printed in the United States of America

Library of Congress Catalog Card Number: 2010933694

For all general information, please contact Arcadia Publishing:
Telephone 843-853-2070
Fax 843-853-0044
E-mail sales@arcadiapublishing.com
For customer service and orders:
Toll-Free 1-888-313-2665

Visit us on the Internet at www.arcadiapublishing.com

For my father, Robert Donald Young, who learned photography from his father and gave me my first camera, a Brownie Flash Six-20.

CONTENTS

ACKNOWLEDGMENTS

How could I start or finish this book without the guidance of Dr. James Scanlon? Only an official "college fossil" would patiently correct and guide me. And how could the photographs be ferreted out from archives without the help of an official college archivist, class of 1984, Judee Showalter? I would not have attempted this project without this dynamic duo by my side. Adding a delightful third to the tripod stabilizing my work was our student assistant Hayley Williamson, who spent a summer working with dusty books and fragile photographs, patiently listening to old stories and researching through a long list of questions.

Thanks also go to Elizabeth Bray at Arcadia for her friendly and helpful emails; Tom Inge, for his past experience as a student editor; and Dale Talley for her voice of experience. Provost Bill Franz is a most encouraging boss, and alumni and marketing staff let me sift through their photographs. Within the library, I had the help of James Murray, master and commander of all things digital; Laurie Preston, head of reference and special collections; Jennie Callas, copy editor extraordinaire; and Emily Bourne, Chris Bryant, Janci Caldwell, Kelli Costain, Scarlett Dodl, Melba George, Megan Hodge, Lynda Wright, and Lily Zhang, who kept the library running in the present while I dabbled in the past. And then, there were all those library student assistants, our future alumni, for whom this book was written. Thank you all.

Unless otherwise noted, all images appear courtesy of the college archives and the Herald-Progress Collection, McGraw-Page Library, Randolph-Macon College.

INTRODUCTION

Randolph-Macon College (R-MC) is the oldest Methodist-related college, founded by Methodists, in continual operation by date of charter (February 3, 1830) in the United States. The college's namesakes were John Randolph of Virginia and Nathaniel Macon of North Carolina; neither was picked for being Methodist or even Christian but for being popular statesmen of the day. The real founders of the college would be Rev. Hezekiah Leigh, whose farm near Boydton inspired the location in rural Virginia across the border from North Carolina, and Bishop John Early, who was president of the board of trustees from 1832 to 1868.

The college opened on October 9, 1832, with five faculty and an estimated 45 students. Rev. Stephen Olin served as both president and professor of moral science. The main building was four stories tall, rivaling the four-story Cushing Hall that Hampden-Sydney College had built in 1822. The Washington Literary Society was founded the first year and continues as a student organization today. When the Franklin Society was formed during the second session, the two became the defining organizations of student life. The societies' books formed the kernel of the college library, and a portrait of George Washington was bought for Washington Hall. College students completed a set course of study leading to a bachelor of arts degree: languages (Latin and Greek), mathematics, natural science, and ethics. English as a subject was taught as early as 1835 by Prof. Edward Sims, who wrote exercises on the blackboard because he could not get textbooks in Anglo-Saxon. Classes relied on student recitations, which culminated in two days of student oratory at commencement. The ability to speak and debate (and preach) was the mark of the Methodist college graduate. The prescribed curriculum was changed to an elective one in 1859, but on February 5, 1863, the college was closed.

Randolph-Macon College reopened in Boydton for the 1866–1867 session with 45 students, but "for the greater prosperity" the trustees voted to remove the college to Ashland, a summer resort 15 miles north of Richmond, along the tracks of the Richmond, Fredericksburg, and Potomac Railroad. A lawsuit to keep the college near Boydton was quashed by General Stoneman, in charge of Military District No. 1 (Virginia) under Reconstruction, who gave permission for the move, and on October 1, 1868, the school opened with four faculty and 67 students under the presidency of Rev. James A. Duncan (1868–1877). During the summer, the furniture, library, lab apparatus, and the Washington portrait had been carted to the new campus on the 13 acres of a failed resort hotel. Coincidentally, the main hall in Boydton had been located in the middle of New Market Race Track, and there was also a racetrack in Ashland.

The main hotel building held classrooms on the first floor and dorm rooms on the second, and many other structures were allocated to new purposes. The ballroom became the chapel and literary halls, and three buildings were used for faculty housing. During the third session,

students raised the money to build a brick hall to house their literary societies and libraries. Washington-Franklin Hall, now fondly referred to as "Wash-Frank," was probably the first brick building in Ashland, and it was quickly followed by two others—Pace Hall for classrooms and Duncan Chapel. The three buildings, on the National Register of Historic Places, still form the core of Old Campus, designated the Jordan Wheat Lambert Historic Campus in honor of one of the four students who led the movement to build Washington-Franklin Hall.

The college was soon known for such innovations as required physical education courses and the teaching of modern foreign languages and English. Pres. William Waugh Smith (1886–1897) established a Methodist educational system with five components under one board. In 1889, Randolph-Macon Academy was built in Bedford, Virginia, to prepare young boys for the rigor of college learning. With the success of the Bedford academy, another was built in Front Royal in 1892. Not forgetting the women, Smith started a women's college in Lynchburg. Opening in 1893, Randolph-Macon Woman's College soon overcame its older brother in national reputation. The fifth member of the system was the Randolph-Macon Institute at Danville, preparing young girls for the women's college. The Bedford and Danville schools were sold off in the 1930s, and the three remaining institutions formally separated in 1952.

Two presidents are responsible for shaping the 20th-century campus. Pres. Robert E. Blackwell (1902–1938) preferred a small student body located in a semi-rural setting and fostered the importance of "hand cultivation" in the education of students. During the 1920s, students in that country setting made their own amusements with crazy clubs and dances. Blackwell added the first brick dormitories and a gym to the campus, and he obtained Carnegie funding for a library. After the Depression, Pres. J. Earl Moreland (1939–1967) led the building of the modern campus: Blackwell Auditorium, Fox Hall, Smithey Hall, and Walter Hines Page Library (allowing the old Carnegie building to become renovated for administration and renamed Peele Hall). These buildings were nearly all constructed east of Henry Street and formed a new focus on campus. The school no longer faced the railroad tracks and in the 1960s developed a new center around the Brown Fountain Plaza, where commencement exercises now take place. During the difficult years of World War II, President Moreland made up for the loss of his (male) students by inviting the Army Specialist Training Program on campus. After the war, he expanded the numbers of students and faculty and built dormitories and dining facilities to house them. During Moreland's presidency, the student body grew from 300 to 560 and the faculty from 15 to 60.

Though admitting many Ashland girls as students as early as Annie and Virginia Cox of Ashland in 1893, Randolph-Macon College remained a male, residential school until 1971, when it went coeducational, five years after African Americans were admitted. Continuities bridge the years as students travel to and from campus by train, play Hampden-Sydney, sport the yellow jacket as their mascot and lemon and black as their school colors, and sing of the oaks and maples on their Ashland campus.

One

BOYDTON YEARS 1830–1868

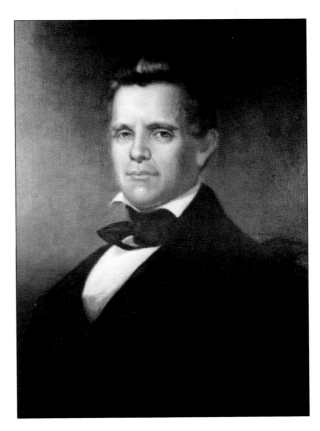

REV. STEPHEN OLIN, 1834–1836. The first president of Randolph-Macon College, Olin oversaw the awarding of the first diploma in 1835 to John C. Blackwell. Converted to Christianity while leading the opening prayer at Cokesbury Academy in South Carolina, Olin came with a doctorate from Middlebury and also taught moral sciences. Olin left the college in 1836 and became president of Wesleyan University, Connecticut, in 1839.

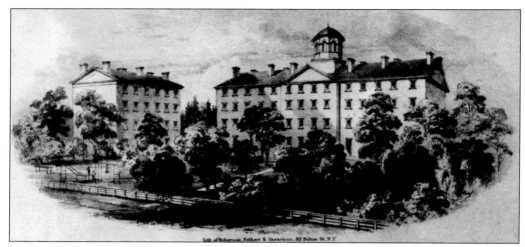

RANDOLPH-MACON COLLEGE, BOYDTON, 1860. The lithograph from a diploma shows the main hall, which housed dormitory, classrooms, library, and chapel, and was built in 1832 for $14,314. The building to its side was constructed two years later, adding 32 new rooms as student numbers grew. The importance of physical fitness in the curriculum is noted by the presence of gym equipment at the lower left.

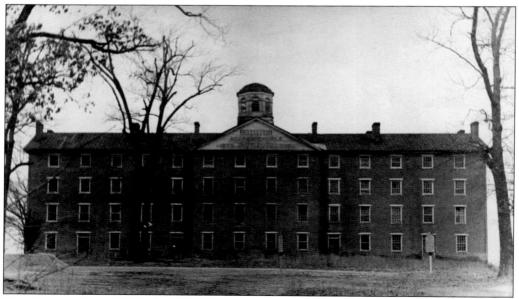

MAIN COLLEGE BUILDING, 1890. The original Randolph-Macon College campus was set on 400 acres in Mecklenburg County, near Boydton, Virginia. After the college moved to Ashland, the former main building housed the Bible Institute for Negroes for many years. The structure is now derelict, but its image remains prominent on the college seal. Students' rooms were grouped around stairwells and given names such as Old Dominion, Prince Street, and Buzzard Roost.

COLLEGE SEAL. The Boydton building, with its cupola and pediment, graces the center of the official college seal, though the school moved away from Boydton after the Civil War. In spite of various logo changes, the design remains the official seal. The phrase Sigillum Collegi Randolph Maconensis in Virginia appears on the oldest diploma in the archives, one signed by the first president, Stephen Olin.

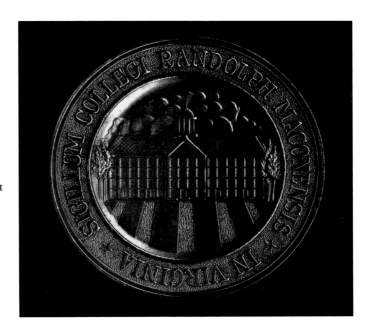

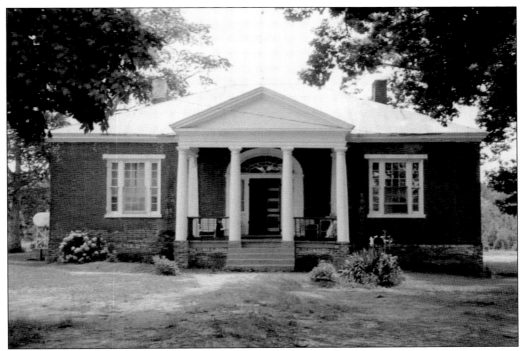

PRESIDENT'S HOUSE, 1979. The President's House was constructed to the west of the main building. Near to it was faculty housing, as the college was too far from Boydton for convenience. A two-story Steward's Hall also stood on the north side of the main hall and served as a dining hall for the students. Clarksville, the nearest large town, was 12 miles away and Petersburg, Virginia, was 70 miles from Boydton.

After having carefully read the laws of Randolph Macon College, I subscribe myself a student thereof. I enter this College with a sincere desire to reap the benefits of its instruction, and with a determined resolution to conform to its laws.

In testimony whereof, I hereunto subscribe my name.

MATRICULATION PLEDGE AND SIGNATURES, AUGUST 1837. "After having carefully read the laws of Randolph Macon College, I subscribe myself a student thereof." Students still sign this pledge at a matriculation ceremony each fall. The matriculation books are an important way to reconstruct the composition of entering classes, as age, student's name, name of parent or guardian, local post office, county, and state were given. Ages of the boys and men ranged from 13 to 26. The amount of preparation each boy brought to the college varied widely, and a preparatory school opened at the same time about a mile away from the college to help increase the numbers of students qualified to start college-level work. States represented on this page include Florida and Georgia besides Virginia.

Date	Age	Students Names	Name of Parent Guard.	Post Office	County	Sta.
	21	Edw. H. Myers	Hezekiah Myers	Tallahassee		Flo.
	21	Jno A Orgain	Sarah Orgain	Lewisville	Brunswick	
	18	Wm H Palmer	R D Palmer	Oakville	Buckingham	Va
	17	D L Pierce	Lovick Pierce	Columbus		Geo
	20	Th. B Russell	Rebecca Russell	Savannah		Ga.
	19	Ed C Robinson	Rebecca Robinson	Jenny Mills	Amelia	
	17	Nat Riddick	Mills Riddick	Suffolk	Virg —	
	16	Thomas P Safford	Dr S P Safford	Madison	Morgan Co	Geo
	19	Wm H Scott	Maj Wm Scott	Milledgeville		Ga
		Jas R Thomas				

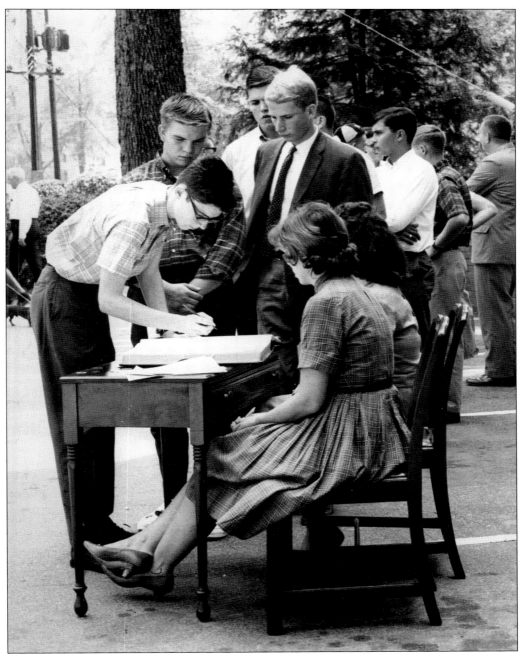

MATRICULATION, 1960s. Students still sign the registrar's official matriculation book, although recent entering classes of close to 400 sign on separate sheets that are bound together afterwards. Though the book signing was discontinued from 1968 to 1980, students now once again attend the matriculation ceremony and sign the pledge during orientation week. The pledge now covers the Code of Academic Integrity as well as the Code of Student Conduct as detailed in the student handbook. Matriculation books are an important document of the college's history and are kept in the registrar's vault.

CERTIFICATE OF SCHOLARSHIP
IN
RANDOLPH MACON COLLEGE.

This is to Certify, That *John Barnard* — of *Currituck county,* and State of *N. Carolina,* having paid to the Trustees of Randolph Macon College the sum of Two Hundred Dollars, is hereby entitled to a Scholarship in said College. This Scholarship confers on him the privilege of having all his Sons—those now in being, and those that may hereafter be born—instructed in the Schools of said College; free from all tuition fees and charges for room rent—each Son being entitled to the privilege of a regular course of instruction, for the term of two years in the Preparatory Department, and four years in the College proper; and having all the rights and privileges of other Students, and being subject to the same regulations and discipline, and no more; nor will the privileges hereby conferred on the Sons, be defeated by the death of the Father in their minority. And if the said *John Barnard,* shall have no Son which he may wish to enter in either of said Schools, then he is authorized, at all times during his life, to have one Student of his own selection in the Preparatory School or in the College proper, as aforesaid. But this Certificate of Scholarship, and the rights which it confers, are in no event assignable or transferable.

In testimony of all and singular, the premises, the Corporate Seal of the Trustees, and the signature of the President of the said College, is hereunto affixed, by order of the Board of Trustees, this the 17th day of May, — in the year of our Lord 1851.

Signed by order and in behalf of the Board of Trustees.

Wm A Smith
President of R. M. College.

CERTIFICATE OF SCHOLARSHIP, 1851. Hoping to raise money for the college, the board authorized certificates of scholarship. Any person paying a certain amount of money, which through the years was $600, then $500, and here, $200, could secure for his son a scholarship in perpetuity to the college. This scheme did not make money for Randolph-Macon.

CATALOGUE, 1839. The fourteen-page catalogue gave the names of trustees, faculty, alumni, and the 94 students at the college, along with their fixed course of studies for their four years. Tuition was $25, and the cost of wood to heat rooms was estimated at $5. One paragraph addressed discipline: "If suitable advice and admonition do not produce speedy reformation, the delinquent will be returned to his parents."

CATALOGUE

OF THE

TRUSTEES, FACULTY AND STUDENTS

OF

RANDOLPH MACON COLLEGE.

OCTOBER, 1838.

RALEIGH:
PRINTED AT THE OFFICE OF THE RALEIGH STAR.

1839.

R.•M.C. Archives

FRESHMAN STUDIES.
FIRST TERM.

Xenophon's Cyropedia, (commenced,)	-	Leipsic.
Cicero, (2 Select Orations,)	- -	Anthon's
Virgil, (The Georgics,) -	- - -	Gould.
Algebra, (Through Quadratics,)	- - -	Bourdon.
Modern Geography, (Reviewed,)	- - -	Mitchell.

SECOND TERM.

Xenophon's Cyropedia, (Completed,)	-	- Leipsic Ed.
Livy, - - -	- - -	Folsom,
Algebra, (Completed,) -	- - -	Bourdon.
Geometry, (6 Books,) -	- - -	Legendre.
Ancient Geography and Mithology, -	- -	- Eschenburg
Porter's Analysis.		

FRESHMEN STUDIES, 1839. Curriculum was prescriptive: all students took the same courses in the same order. Beginning with a firm grounding in Latin and Greek, students added trigonometry and navigation as sophomores, chemistry and mechanics as juniors, and optics, astronomy, political economy, and mineralogy as seniors. In 1859, the college made biblical literature available to students who wished to take it, instituting a major shift to an elective curriculum.

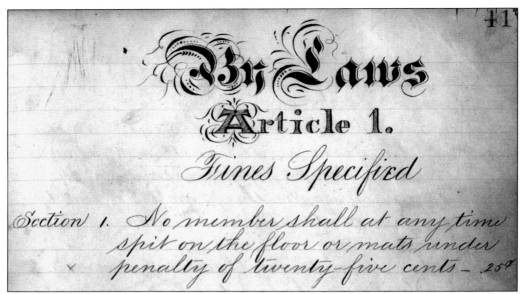

By Laws

Article 1.

Fines Specified

Section 1. No member shall at any time spit on the floor or mats under penalty of twenty-five cents – 25¢

BYLAWS, 1883. The Washington Literary Society was founded during the first session of the college and the Franklin Literary Society in the second. Every student was a member of one or the other, and the 10 officer positions included a librarian and an archivist; the two book collections were the beginning of the college library. Literary societies kept a constitution and bylaws as well as minutes.

MINUTES BOOK, 1861. Debates, orations, essays, and declamations were an important part of college life. Questions included current topics, as illustrated by the one here from March 15, 1861. Others would be relevant today, such as, "Should capital punishment be abolished?" from 1848. Students were assigned affirmative and negative sides; prizes were given, and every student gave a speech at commencement.

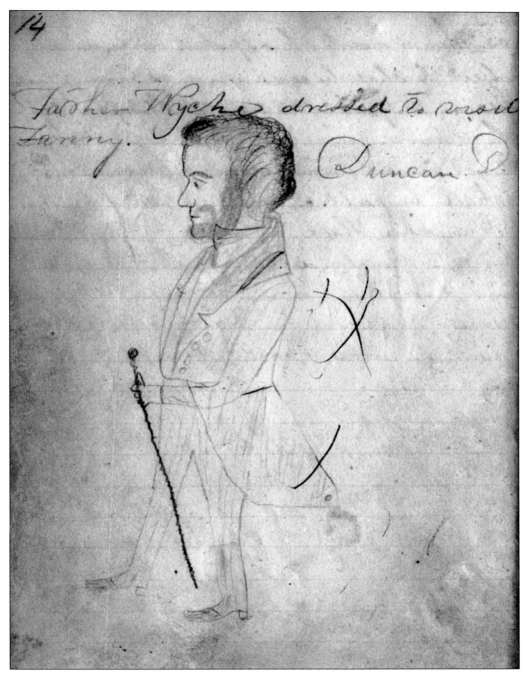

FATHER WYCHE, 1840s. Among the elaborate ink calligraphy of the constitution of the Franklin Literary Society are penciled scribblings. After listing 25 regulations, the secretary sketched a caricature of a fellow student, possibly George Wyche. From North Carolina, Wyche matriculated in 1837 at age 15 and graduated in 1842 along with Thomas Johnson, fourth president of the college, and became a Methodist minister. His "Fanny" also appears in the book, dressed for a ball.

KNOW ALL MEN BY THESE PRESENTS, That I, *Jas. C. White* am held and firmly bound to the

Trustees of Randolph Macon College in the sum of *Twenty five* dollars, to be paid to the said Trustees or their Agent. For the true payment of which I bind myself, my heirs, &c., firmly by these presents.

THE CONDITION OF THE ABOVE OBLIGATION IS SUCH, That in the event the Trustees of Randolph Macon College shall raise the endowment fund of said College, in bonds, cash and valid subscriptions, to the amount of *one hundred thousand dollars*, of which said Trustees shall give due notice, on or before the 1st of January 1859, through the newspapers of the State, then this obligation shall be binding, otherwise it shall be void.

Given under my hand and seal this *10* day of *Oct* 1857.

James C. White [SEAL.]

Charlottesville Va.

PATRON'S BOND, 1857. In a campaign to raise $100,000 for the endowment, Pres. William A. Smith asked for subscriptions from along the Methodist circuit. If the $100,000 was pledged by January 1, 1859, then the subscribers would be asked to fulfill their pledge. As the 1850s were prosperous for Virginians, the amount was raised by December 1858. The bonds received were filed by geographic location in a linen case.

Two

REBIRTH IN ASHLAND
1868–1902

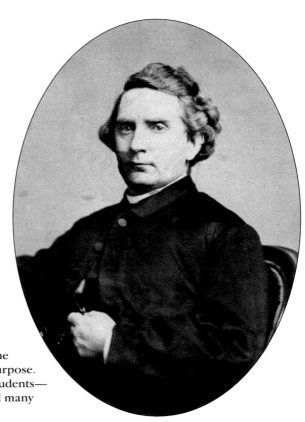

REV. JAMES A. DUNCAN, 1868–1877. After the Civil War, Randolph-Macon moved to a more accessible location in Ashland, Virginia. The fifth president opened the college in Ashland with 67 students and four professors. Duncan, himself an alumnus of 1849, adapted the buildings of a resort hotel to college purpose. Through his preaching, he recruited students— even from other schools—and inspired many future Methodist preachers.

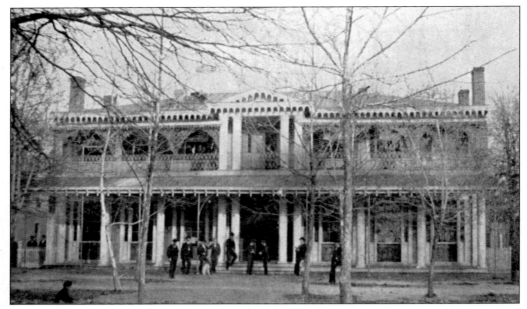

"INDEPENDENCE HALL," 1868–1875. On October 1, 1868, the college opened on the grounds of a former resort hotel, which included 13 trackside acres in Ashland. The main hotel building became a dormitory, with lecture rooms on the first floor. The old ballroom became a chapel. The student building committee for Wash-Frank Hall stands on the steps, while one student is perhaps digging a hole.

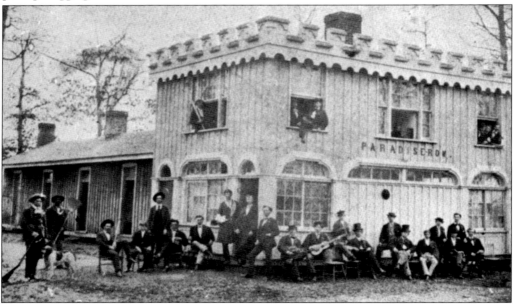

PARADISE ROW, 1868–1886. Paradise Row, formerly a bowling alley for the hotel, and its mate Old Dominion Row became dormitories for the new college. Capt. Richard Irby stands on the far left, with dog and hunting rifle. In 1898, he published the first history of the college. Other students wear top hats and hold musical instruments. President Duncan oversaw a college with 67 students and four professors.

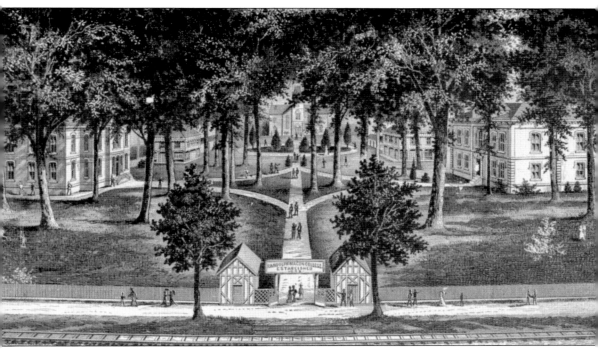

CAMPUS, 1880. This engraving shows the gatekeeper sheds on the single railroad track. The buildings, from left to right, include Pace Hall, Old Dominion Row, Duncan Memorial Chapel, Paradise Row, and the Hall of the Literary Societies. Oaks and maples shade the grounds, and the circular planting bed in front of the chapel still decorates Old Campus today.

RICHMOND, FREDERICKSBURG, AND POTOMAC RAILROAD, 1899. The railroad company developed Ashland as a resort area for Richmond and owned much of the land. Anticipating increased business, it sold the hotel and land to Randolph-Macon. The college also held the racecourse property farther south but later exchanged it for land to the west of the campus, when brick buildings committed the school to its present location.

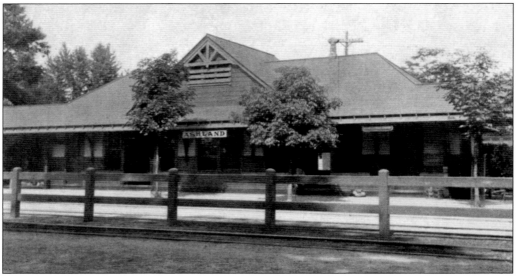

ASHLAND DEPOT, 1909. The depot on the Richmond-Washington Line was on the east side of the tracks at this time. This photograph was taken after 1903, because there was only one set of tracks until that year. The depot survived into the 1960s, when it was torn down. Now a college parking lot and street parking for commuters into Washington, D.C., are on the site.

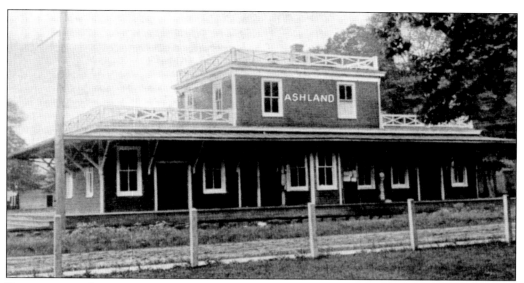

RICHMOND AND CHESAPEAKE BAY RAILWAY COMPANY, 1907–1938. A quick way for R-MC students to get into Richmond was to buy a ticket on the electric car line. Running from 1907 until 1938, this electric trolley made Ashland a suburb. Bearing a strong resemblance to the Henry Clay Inn, the station was demolished in 1938, and a brick post office was built on the site.

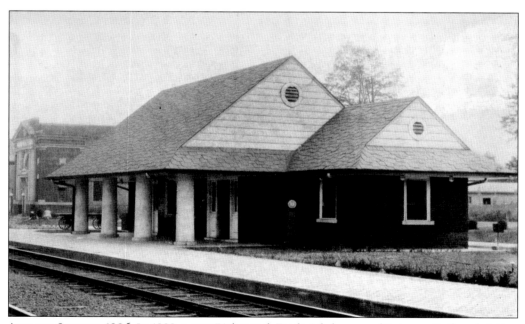

ASHLAND STATION, 1926. In 1922, a new Richmond, Fredericksburg, and Potomac Railroad station was built on the west side of the tracks. The slate-roofed structure had a rigidly symmetrical layout, with a "whites" waiting and baggage rooms on the north and a "colored" set on the south side. This building now serves as the Ashland/Hanover Visitor Information Center, but Amtrak continues to stop for passengers.

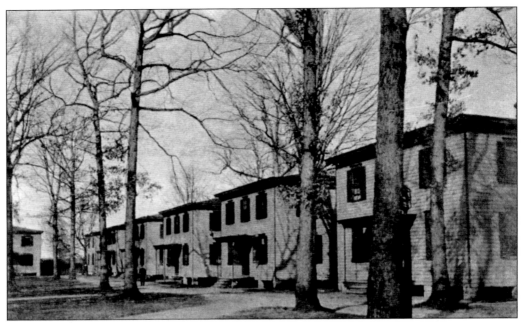

COTTAGES, 1909. Eight cottages, known by their numbers, were constructed for student housing from 1883 to 1885, replacing the older hotel cottages. No. 9 was the last; it survived into the 1930s. Later some cottages formed Fraternity Row and others became faculty houses. Heated by stoves, they did not have basic sanitary facilities and did not survive the introduction of centralized steam heat.

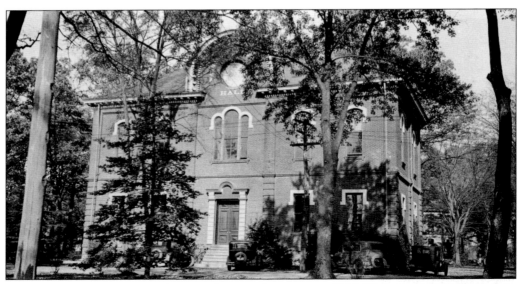

HALL OF THE WASHINGTON AND FRANKLIN LITERARY SOCIETIES, C. 1890. Wash-Frank Hall was built in 1872 and funded by the students themselves to house the meeting rooms, books, furniture, and papers of the two literary societies. The principal student leader was Jordan Wheat Lambert of the Franklin Literary Society. Lambert would later show his business acumen by marketing Listerine, and the hall would be restored in 1987 by his granddaughter Rachel Lambert Mellon.

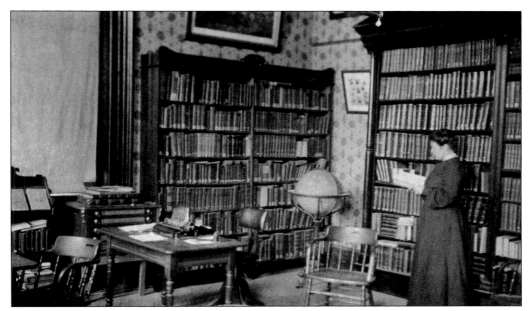

LIBRARY, 1904. On the second floor, Wash-Frank Hall housed the college library, which began as the collection of books brought from Boydton by the two literary societies. Its 15,000 books and 40 current journals were available to students from 9:00 a.m. to 10:00 p.m. daily—generous hours in those days. Carrie Ellis Hartsook served as librarian until Nancy Sydnor came when the Carnegie library was built in 1923. Hartsook then became registrar. Books were assigned fixed locations, by alcove (bookcase), shelf, and book number. Bishop John C. Granbery, class of 1848, wrote in 1882 that students "studied carefully the questions of debate, reading largely, and thus forming a fondness for books and habit of reflection."

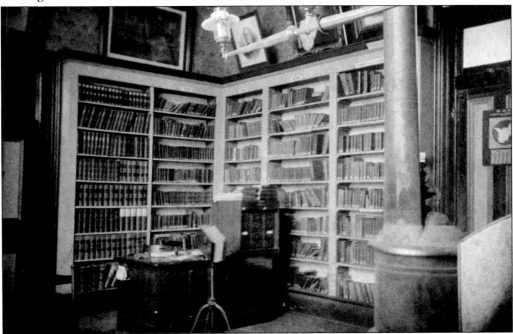

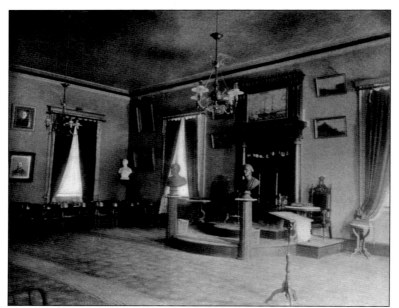

WASHINGTON HALL, 1900. On the west side of the first floor, Washington Hall was distinguished by a painting (above the mantel) of a silver clipper representing the ship of state, which appears on the seal and medals of the society. The Greek motto below the ship translates as "He is anchored by two things: intelligence and virtue."

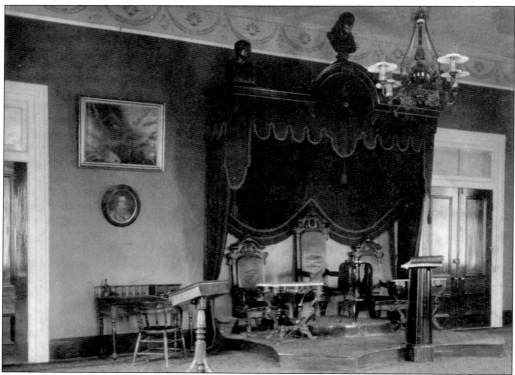

Franklin Hall, 1900. On the east side of the first floor was Franklin Hall. A portrait of Robert E. Lee hung by the dais, and above were busts of Franklin, Cicero, Virgil, and others. The literary societies were the principal organization of the student government and the scenes for orations, declamations, and debates, such as "That the United States should Adopt a Minimum Wage Law for Unskilled Labor" in 1915.

FRANKLIN AND WASHINGTON LITERARY SOCIETIES, 1909. As students were required to be members of one or the other literary society, the societies had more members than fraternities. Gentlemen in the two societies spelled out their affiliation in these photographs from the 1909 yearbook. Below, President Blackwell sits in the front center of the "F," his society from his student days. Curiously, these photographs were not taken in front of Wash-Frank Hall but at the Henry Clay Inn, a popular meeting place west of the campus.

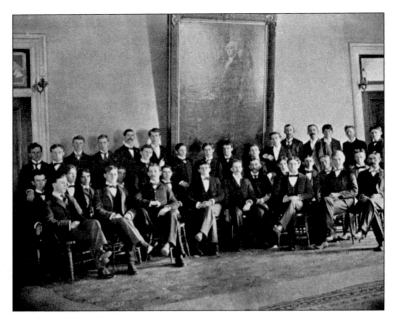

WASHINGTON HALL, 1898. In Washington Hall hung a life-size reproduction of the famous Gilbert Stuart portrait of George Washington. It was purchased by the 60 members of the literary society in 1835 for $380, an expensive item at the time. The painting was commissioned from an artist in New York City and brought back by President Olin in an oxcart, as depicted in 1976 in a mural in Fox Hall.

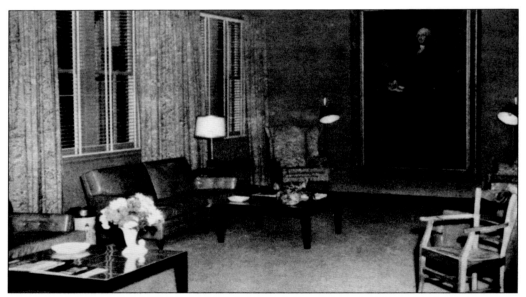

ALUMNI HALL, 1958. When Wash-Frank Hall was condemned in 1952, this portrait hung in Alumni Hall, a wing of Old Chapel. Gertrude Hatcher Sloan, alumni secretary from 1941 to 1965, had her office there. Her father, Dr. Samuel C. Hatcher, served as vice president and treasurer of the college for 36 years and as acting president after Blackwell's death. In 1919, his daughter Gertie began setting up alumni files and records.

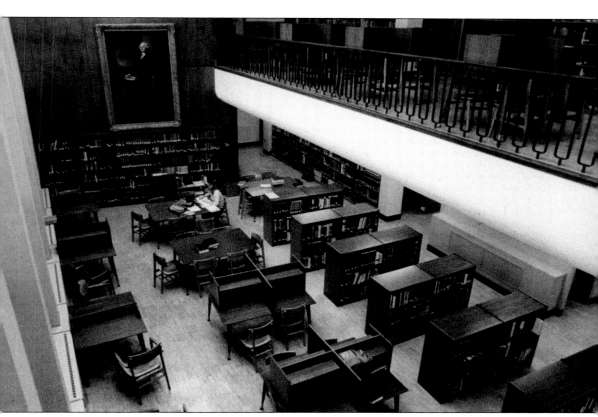

WALTER HINES PAGE LIBRARY, 1983. In 1961, the Washington portrait found a home in the new Walter Hines Page Library, designed with a mezzanine floor that provided a lovely spot for the large portrait. When the Wash-Frank Hall was restored in 1987, the portrait returned to its home on the walls of Washington Hall.

PACE HALL, 1922. Donated by James B. Pace in 1877, the second new structure on campus held lecture rooms for English, Latin, modern languages, history, and moral philosophy and English Bible. On the first floor was laboratory space for chemistry and a museum for geological specimens. "Natural philosophy" was the general term for sciences, but in 1870, chemistry was separated from physics. Below are junior students at work in the chemical laboratories.

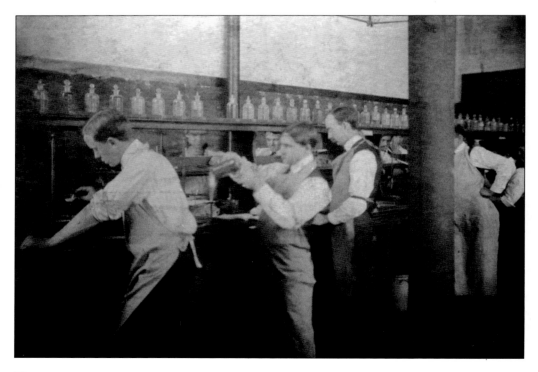

OLD CHAPEL, 1900. The first chapel was in one of the resort buildings. After it burned, Duncan Memorial Chapel was constructed in 1879 and named for the first president at the Ashland campus, Rev. James A. Duncan. The first floor was for college use, and the second floor was Duncan Memorial Methodist Church for the Ashland congregation. The front door was on the west side, facing the railroad.

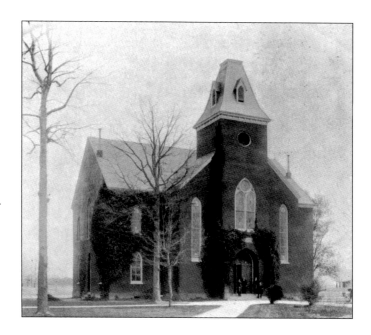

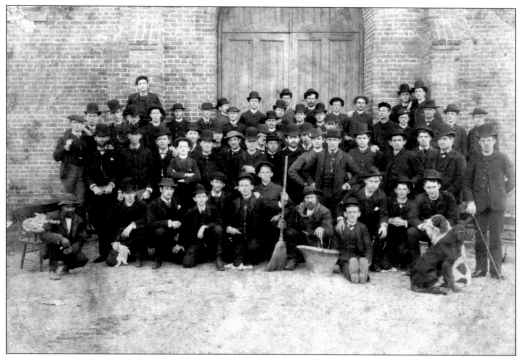

AFTER CHAPEL, 1886–1887. Although students attended chapel every morning in Boydton, they went to chapel three days a week in Ashland. Compulsory attendance ended in 1969. Posing with the faculty and students are the custodians, including Judge Crawley with his broom and coal scuttle. Crawley was born in Caroline County, fought in the West with the U.S. Cavalry, and returned to serve the college for over 27 years.

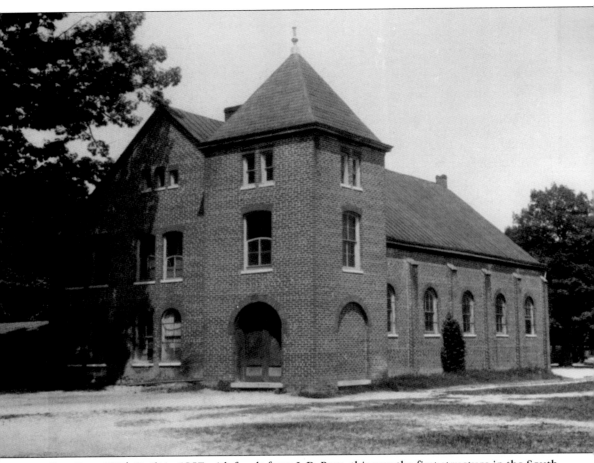

OLD GYM, 1914. Built in 1887 with funds from J. B. Pace, this was the first structure in the South to be constructed solely for instruction in physical education. Pres. W. W. Smith brought to the college both a system of physical training and lectures on hygiene given by the college physician. A year of physical education was required for graduation.

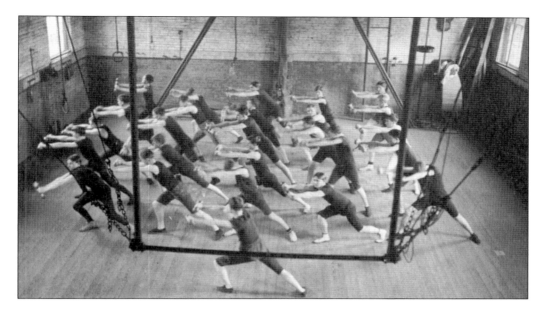

GYMNASTICS, 1904. Randolph-Macon promoted "Systematic Physical Culture." Below is the gymnastics team from 1900. Inside the Old Gym, students worked with equipment at regular training exercises. There are long balance sticks among the dumbbells, Indian clubs, balls, and other equipment. The emphasis was on movement with light weights for healthful calisthenics. There was also an annual field day, with standing and running broad jumps, relay races, hurdles, tennis, dodgeball, and something called a pick-a-back race. In 1904, Samuel Duke was named "All-Around Champion of Meet," and a Miss McCullen was "voted by contestants, fairest lady on field."

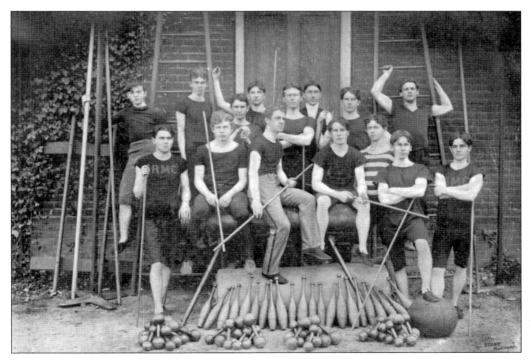

PETTYJOHN SCIENCE HALL, 1916. The fourth building to be added to the campus was the Pettyjohn Science Hall, donated by John P. Pettyjohn, a member of the board of trustees. Constructed in 1890, the structure housed the lecture room for Greek and laboratories for biology, mathematics, and physics, with an observatory on top. Pettyjohn Hall remained standing until 1976.

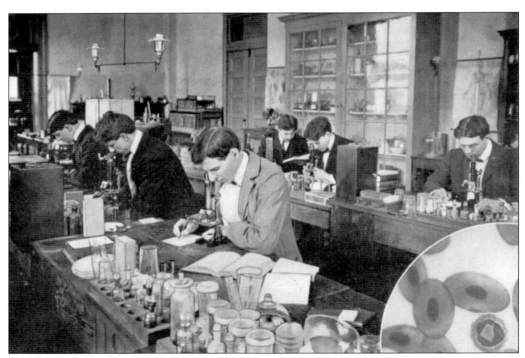

BIOLOGY LAB, 1902. Inside Pettyjohn, students worked with the latest equipment, incubators, and microtomes, and a library held books and current journals. In 1887, the college became the first in the South to distinguish biology as a discipline, and Benjamin Sharpe was appointed adjunct professor of biology.

PRESIDENT WILLIAM WAUGH SMITH, 1886–1897. President Smith was responsible for making physical culture a part of the college curriculum, but his main project was the formation of the Randolph-Macon System. Smith faced a shortage of qualified students and started private secondary schools. He also favored education for women. In 1897, he became chancellor of the system but continued to serve as president of the women's college. Smith served as chancellor until his death in 1912. The system lasted until 1952, when the three surviving institutions formally separated. (Portrait courtesy of Lipscomb Library, Randolph College.)

ᴛʜᴇ RANDOLPH-MACON SYSTEM OF

COLLEGES ᴀɴᴅ ACADEMIES.

.WILLIAM W. SMITH, A. M., LL. D., Chancellor.

1. **RANDOLPH-MACON COLLEGE,** Ashland, Va., founded 1830.

2 and 3. **RANDOLPH-MACON ACADEMIES,** at Bedford City, and Front Royal, prepare for any College or University or for business. Both eligibly located. The buildings, with grounds, etc., at each place, are worth $100,000, and are unequalled in the South. Heated by steam, lighted by electricity; bath rooms with hot and cold water on every floor; single beds; single desks; classes limited to fifteen pupils. Splendid gymnasiums. Rates low.

FRONT ROYAL ACADEMY, now in the special care of Pres. W. W. Smith, at the request of the Conference, is the male school of the Baltimore Conference. For circular with full particulars address Principal R.-M. Academy, Front Royal, Va.

BEDFORD CITY ACADEMY, E. Sumter Smith, Principal, is under the peculiar care of the Virginia Conference. For catalogue with full particulars address Principal R.-M. Academy, Bedford City, Va.

4. **RANDOLPH-MACON WOMAN'S COLLEGE,** at Lynchburg, Va., offers to the young women of the South, facilities for education equal to those afforded young men at Randolph-Macon College at Ashland. One hundred and three thousand dollars already secured for its endowment. Buildings, costing $132,000, are provided with all modern comforts, gas, steam, water. It is strong, permanent, well equipped and progressive. For particulars, address President Woman's College, Lynchburg, Va.

5. **RANDOLPH-MACON INSTITUTE,** Danville, Va., offers a superior Seminary course with excellent facilities. Prepares for entrance into advanced classes as the Woman's College.

For catalogue, apply to the President, or Principal of the several schools.

126

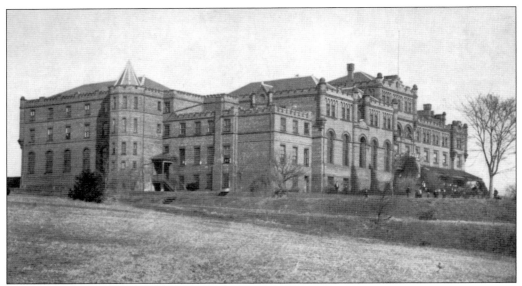

RANDOLPH-MACON ACADEMY, BEDFORD, 1909. Smith's first step toward the system came in 1890, when the city of Bedford offered land and money for a high school. Although located more than 100 miles from Ashland, the academy became a feeder school to Randolph-Macon College. The imposing Romanesque-style building was designed by the Washington, D.C., architect W. W. Poindexter. Financial hardships during the Depression led to its sale in 1936.

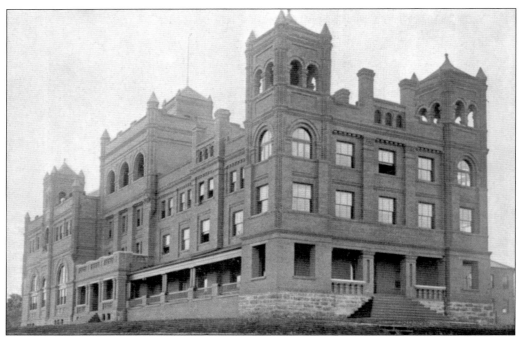

RANDOLPH-MACON ACADEMY, FRONT ROYAL, 1892. In 1892, Smith opened a second academy on 15 acres in northern Virginia at Front Royal. Again, Poindexter was the architect. This building burned in 1927, but the rebuilt academy is still in existence as a college-prep boarding school, coeducational since 1974 and offering Air Force JROTC.

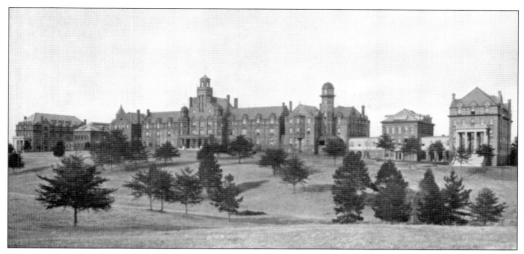

RANDOLPH-MACON WOMAN'S COLLEGE, 1909. Unable to convince the board to have coeducation, Smith started a sister institution in Lynchburg in 1893. Built on land from the Rivermont Land Company with Poindexter as architect, Randolph-Macon Woman's College (RMWC) soon outshone its older brother. RMWC became Randolph College in 2007, when it went coeducational.

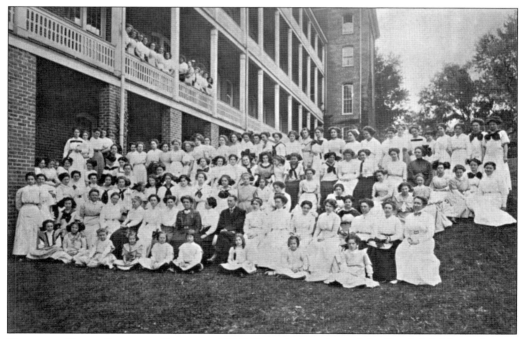

RANDOLPH-MACON INSTITUTE, DANVILLE, 1897. The missing piece of the Randolph-Macon System was a female preparatory school. The board of trustees and President Smith bought the Danville Institute for Young Ladies (1854) to be a feeder for the women's college. The weakest member of the system, the institute was sold in 1930 to operate as Stratford College, which closed in 1974 to become a retirement center.

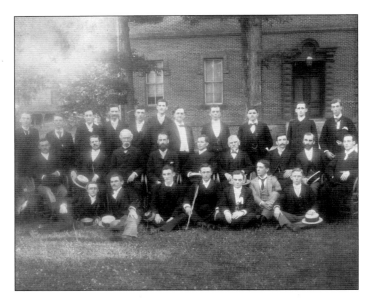

CLASS OF 1890. Faculty seated in the second row among their students include, from the left, Professors Crenshaw, Smith, Buchanan, Blackwell, President Smith, and Professors Shepard, Smithey, and Kern. The gym built in 1964 was named for Dr. John Crenshaw, physical education instructor from 1886 to 1890, and the mathematics-physics building of 1951 for R. B. Smithey. Later Kern served as president from 1897 to 1899 as did Blackwell from 1902 to 1938.

CLASS OF 1896. Nicely numbered and identified, this class photograph includes students with their diplomas, along with President Smith (no. 17); two professors (and future presidents): Kern (no. 16) and Blackwell (no. 7); Professors Knight (no. 6), Bowen (no. 13), Easter (no. 14), Smithey (no. 18), and Wightman (no. 20); and chaplain Judkins (no. 19). The photograph is from the *History of Randolph-Macon College*, which Richard Irby, secretary and treasurer (no. 15), published two years later, in 1898.

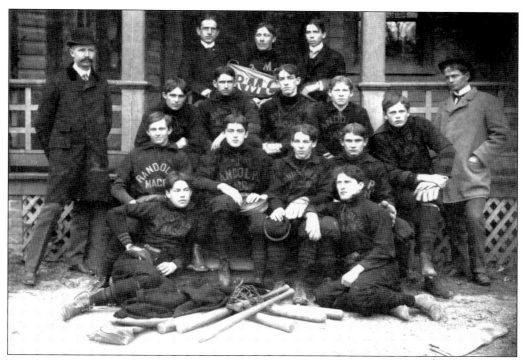

BASEBALL TEAM, 1900. Charles Thrift, 1902, told the story of the triple play during the game with Richmond College on April 2, 1900. By the fifth inning, R-MC was ahead 5 to 4 when pitcher Haden threw the ball to White. Lavender caught the ball for the first out, tagged out the runner to second, and then threw to Green, who tagged out the runner coming back to second.

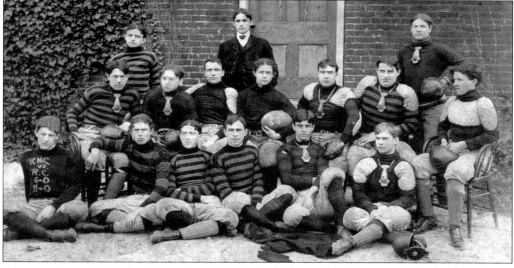

FOOTBALL TEAM, 1901. On December 3, 1881, the Richmond College team traveled by train to Ashland to play its first football game against another college. Between 10:00 a.m. and 9:00 p.m., the teams played three games. Unfortunately for R-MC, Richmond won all three contests. But in the fall of 1901, Randolph-Macon reversed the results and beat Richmond 6-0 and 11-0, as written on shirt and football.

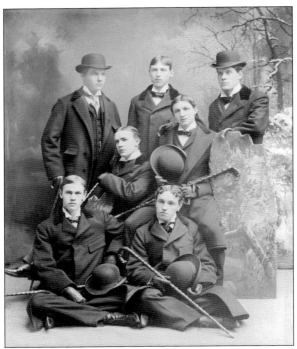

GAMMA GAMMA CHAPTER, SIGMA CHI, 1894–1895. Presented to Mary Blincoe, the chapter sweetheart, this studio portrait includes these dandy students. They are, from left to right, (first row) Henry A. Christian and Albert H. Licklider; (second row) A. C. Southall and P.H. Drewry; (third row) W. S. Danna, James Mullen (future chair of the board of trustees), and S. H. Watts.

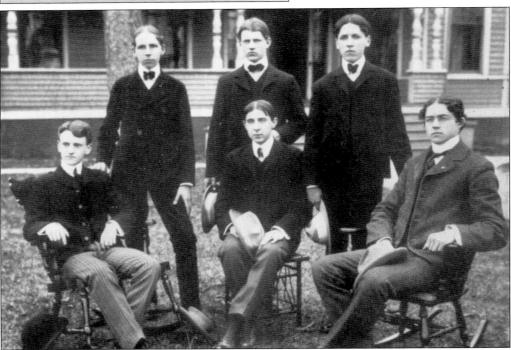

KAPPA ALPHA, 1901. The oldest surviving fraternity on campus is Kappa Alpha (KA), Zeta chapter, founded in 1869. Jordan Wheat Lambert (not shown) was a KA in 1870 and later marketed Listerine under his pharmaceutical company. His portrait hangs in Wash-Frank Hall for his role in its building in 1872 and his granddaughter's role in its renovation in 1987.

KAPPA ALPHA HOUSE, BEFORE 1930 AND IN 1962. Although many fraternities have switched houses through the years, Kappa Alpha has had two exclusive houses. The first, a wood frame house, was built by student W. W. Smith. In 1930, Old Stone Fort was built and has remained with the KAs. Built of stone and facing the railroad tracks, the house is distinctive and its interior appeared in the television movie *My Name is Bill W.* It is also known as Lambert Hall for the portrait of member Jordan Wheat Lambert that hangs there. At first, students were allowed only to meet in their fraternity houses, but later they were permitted to use them as residences.

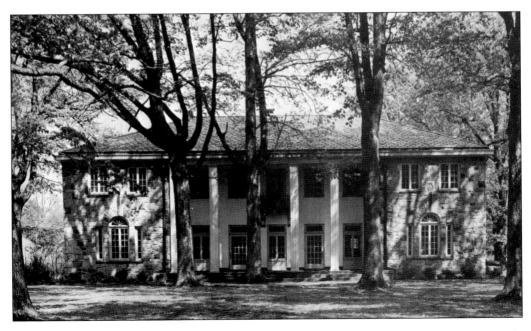

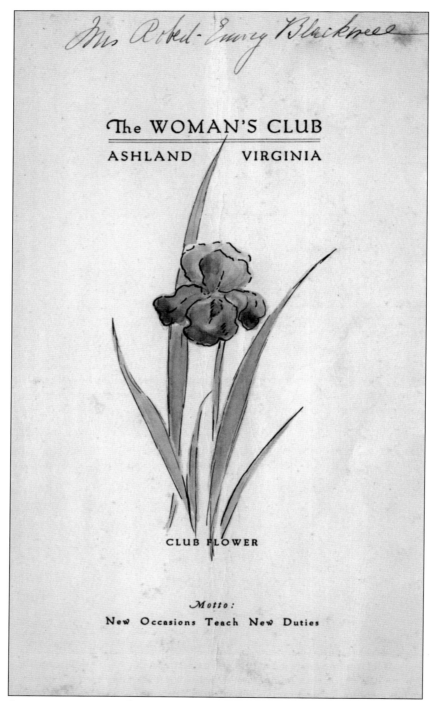

Mrs. Robert Emory Blackwell

The WOMAN'S CLUB
ASHLAND / VIRGINIA

CLUB FLOWER

Motto:
New Occasions Teach New Duties

WOMAN'S CLUB OF ASHLAND, 1896. The Woman's Club was organized by single and married ladies of Ashland to discuss the current topics of the day. Of the 14 founding members, Mary Virginia Kern was the wife of the president of R-MC, and Epie Blackwell and Annie Smithey were the wives of professors.

42

WOGGLE-BUG CLUB, 1905. Epie Duncan Blackwell would reign in her own right as president of the Woman's Club from 1902 until her death in 1929. The daughter of one R-MC president and the wife of another, she also was a member of the Woggle-Bug Club. Here she sits with her daughter (third row, beside her), husband, mother-in-law (opposite her), and students. The Woggle-Bug was a character in the *Oz* books by L. Frank Baum.

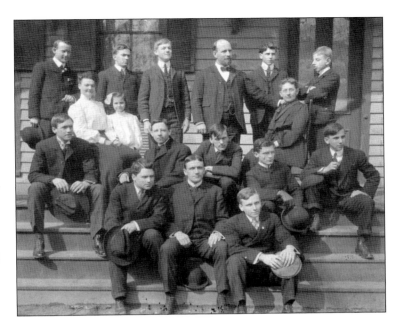

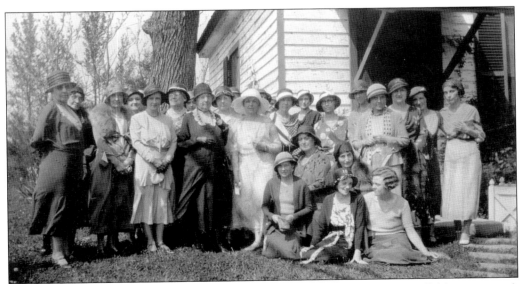

WOMAN'S CLUB, 1933. Through the years, presidents' and professors' wives, staff, librarians, and, now, women faculty have been members. The Woman's Club meets every Tuesday at 4:00 p.m. from October to April to hear papers written by the members. The annual program lists the schedule of talks and bears the club flower, the iris; the club colors, purple and gold; and the club motto, "New Occasions Teach New Duties."

YELLOW JACKET LOGO, 1899. The *Yellow Jacket* appeared as the first R-MC yearbook in 1899, predating the name's use by Georgia Tech. The yellow jacket is the athletic mascot and also the name of the student newspaper. The Yellow Jacket Club is the group "through which alumni, friends, and parents can support the intercollegiate athletic programs of the College on a continuing basis."

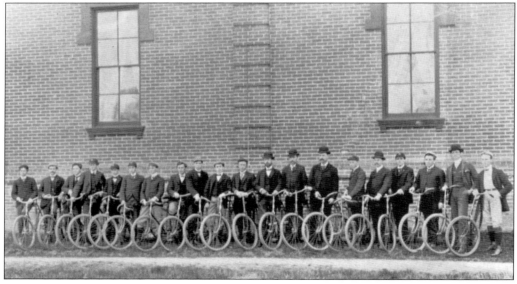

BICYCLE CLUB, 1899. W. A. Wheary was president of the bicycle club, listed along with the tennis and glee clubs in the 1899 yearbook. Members include M. F. Messick, who later married President Blackwell's daughter; T. McNider Simpson, then a student and later professor and dean; and professors R. E. Blackwell and R. B. Smithey. Ashland Coffee and Tea is today's popular destination for weekend cyclists from Richmond.

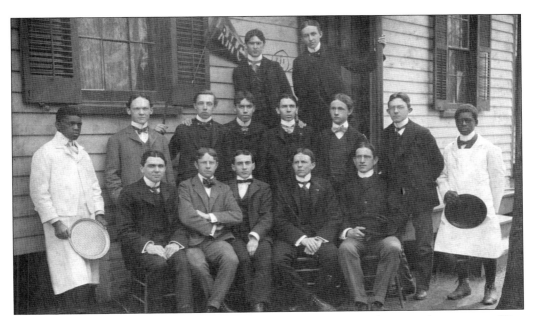

SATURDAY-NIGHT EATING CLUB, 1900. Founded in September 1898, this group's motto was "Eat, drink, and be merry, for tomorrow!" Listed in the 1900 yearbook, officers included Lord High Chief Epicure, Lord High Eat-What's-in-Sight, and Lord High Can Opener. At a time when students contracted their meals at Ashland boardinghouses, joining together for late-night suppers let "the shrill notes of grinding text-books die away in the more melodious song of clinking glasses."

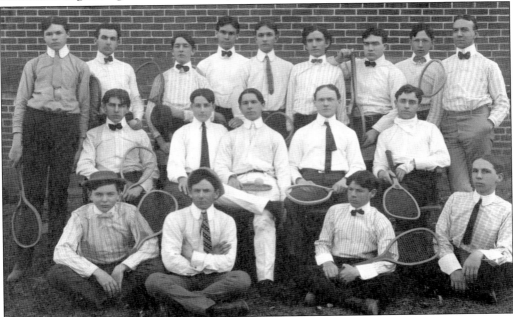

TENNIS CLUB, 1890s. Tennis was always a popular club sport on campus, but the courts have had many locations. Courts were built beside Thomas Branch Dormitory, later moved east of Henry Street, and then west across the tracks. In 2010, a new tennis complex was constructed along Henry Clay Road.

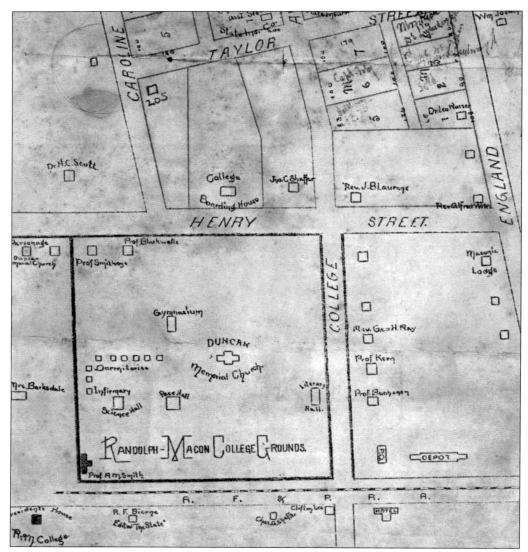

LOTS OF THE ASHLAND LAND IMPROVEMENT COMPANY, 1890–1897. Trying to sell real estate, agent Clifton Lee noted the layout of the adjoining college. This map shows how small and contained the college was in the late 19th century. There was still only one railroad track, and the passenger depot was east of the tracks. Kern and Blackwell were professors, and Smith resided in the President's House (currently the Treasurer's Office). At the bottom, Beirne's house (misspelled on the map), called Rhodeen after his ancestral home, was the home of the editor of the Richmond newspaper, *The State,* but it is now the Development Office. Pettyjohn Hall of Science exists, but the cottages were used as dormitories before Mary Branch was built. (Courtesy of the R-MC Alumni Office.)

Three

BLACKWELL ERA
1902–1938

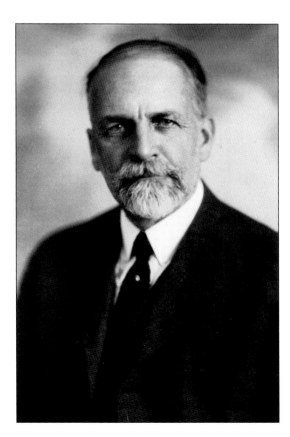

ROBERT EMORY BLACKWELL, 1902–1938.
A student at the college from 1868 until
earning a master's in 1874, Blackwell
returned from studies in Leipzig in 1876
and remained at Randolph-Macon until
his death in 1938. He was a professor of
English and continued to teach after he
followed Reverend Starr in the presidency.
Besides his service to the college, he
was founder and chair of the Virginia
Commission on Interracial Cooperation.

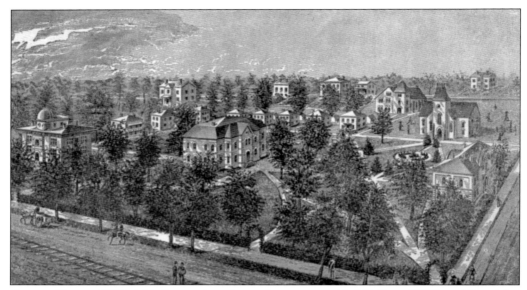

CAMPUS, BEFORE 1903. A bird's-eye view shows the campus with Old Gym (1887) and Pettyjohn Hall (1890), and athletes out on the playing fields behind Old Chapel. But this view predates the double railroad tracks of 1903, and where Mary Branch Dormitory will be in 1906, cottages line up, built to replace Old Dominion Row and Paradise Row, the old hotel buildings.

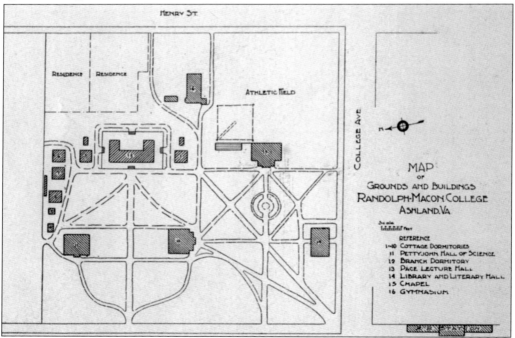

MAP OF GROUNDS AND BUILDINGS, 1906. This plan shows a compact campus, with Pace Hall for lectures, Pettyjohn for science, literary halls with library, the chapel, and the gymnasium on the edge of the athletic fields. On the north side are the cottage dormitories and the newer Mary Branch Dormitory. The illustrated viewbook encouraged admissions by noting that the "location is distinguished for healthfulness and accessibility."

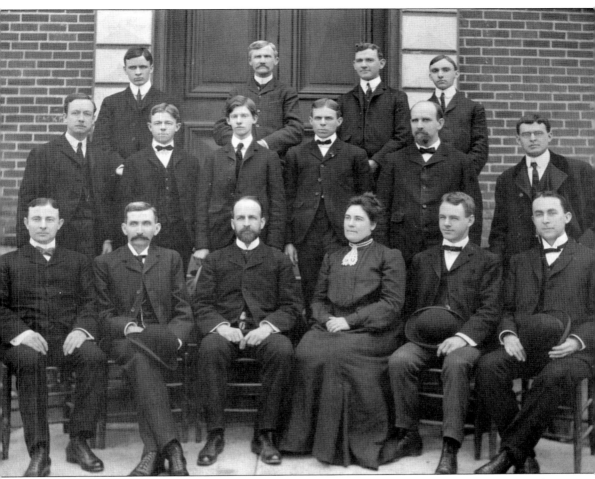

FACULTY, 1904. The faculty included President Blackwell, who also taught English and French; Professors Smithey for mathematics; Bowen for Latin; Wightman for biology and physics; Edwards and Duncan for moral philosophy and biblical literature; Jones for Greek and German; Dodd for history and economics; Canter for chemistry, geology, and astronomy; five student instructors; and Carrie Ellis Hartsook, college librarian.

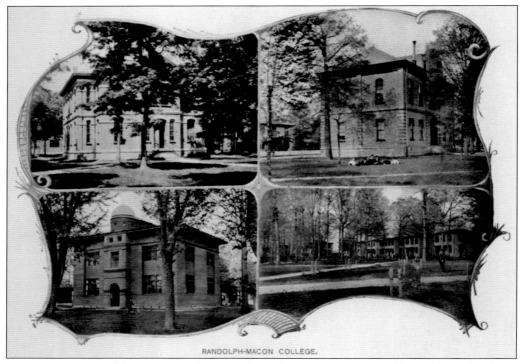

RANDOLPH-MACON COLLEGE.

CAMPUS VIEWS, 1906. Picturesque photographs of the campus were used in early viewbooks to entice prospective students, as viewbooks still do today. The medallion above shows on the top left Pace Hall and Wash-Frank Hall, which today house the fine arts and history departments, respectively. Pettyjohn Hall of Science was replaced with Copley Science Building on the other side of campus, and later dormitories replaced the cottages. The medallion below includes the Blackwell House, top left, which served as the President's House then and is the Business Office today. The other buildings no longer exist: a new Ashland passenger station was built in 1922, Professor Smithey's house was torn down to make way for the Campus Center, and the cottages were gone even before the Old Gym was torn down in 1976.

PRESIDENT'S HOUSE, PROFESSOR'S HOUSE, GYMNASIUM, RAILROAD STATION, ASHLAND, VA.

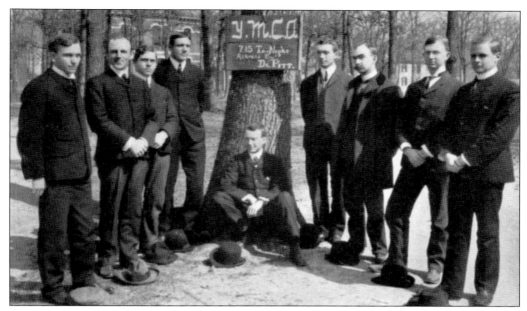

THE YMCA, 1905. Formed shortly after the literary societies, the YMCA was also a strong group on the Ashland campus. The club had a cabin on a lake that remained a popular meeting spot. Committees organized devotionals, Bible studies, missionary works, music, and in the fall, the members always had a reception for freshmen, faculty, and town girls "in ribbons and white dresses" in order to get acquainted.

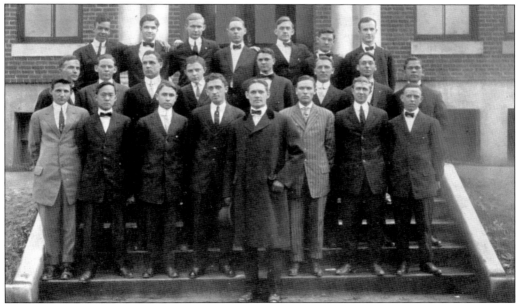

MINISTERIAL BAND, 1911. Nicknamed "Biblits," the Ministerial Band poses for a club photograph. It sometimes fielded an intramural baseball team. Stephen Dulaney, nicknamed "Duly," was president in 1911 and was lauded in his senior bio as "Duly to be—a kind and beloved pastor." The numbers of ministerial candidates may be fewer these days, but A. Purnell Bailey Scholarships support those men and women who are preparing for ordination.

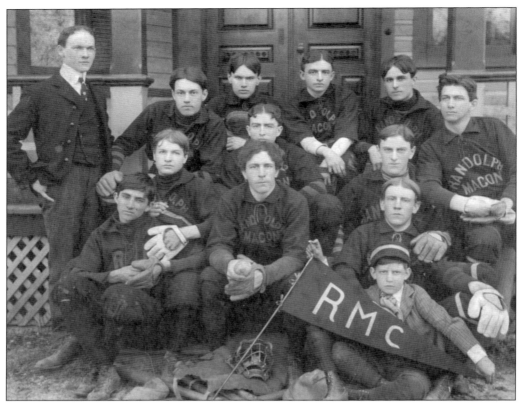

BASEBALL TEAM AND FIELD, 1902. The saga of the baseball team was put into poetry for the 1902 yearbook: "Our baseball team it was a peach / We walloped everything in reach / And when the season had wound up / We held first place, and won the cup." The baseball field lay on the future grounds of the Carnegie library and Thomas Branch Dormitory and was the field where the Yellow Jackets won the championship of Eastern Virginia. The stands were located on the north side of Old Chapel, and the horse and buggies traveled along Henry Street, beyond left field. In 1937, the college acquired the land north of Alumni Gym from Dr. Frank Day for athletic fields. In 2011, a new baseball field, the Hugh Stephens Field at Estes Park, opened farther to the north.

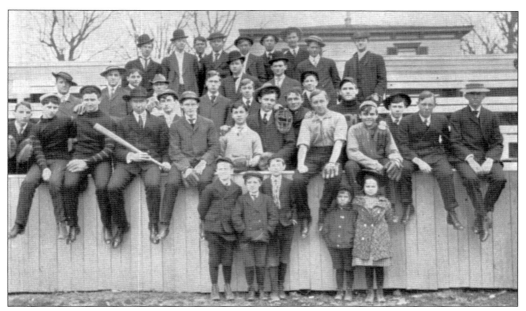

EGYPTIAN LEAGUE, 1906. Intramural teams were also included in the sports section of the yearbook. The Egyptian League was a more informal baseball organization. In the 1906 yearbook, three teams are pictured: Maranders, Biblits, and Muckers, each with a president and a secretary/treasurer. Joining the team are several neighborhood children. Other team names through the years were the Ptolemies, the Assyrians, and the Numidians.

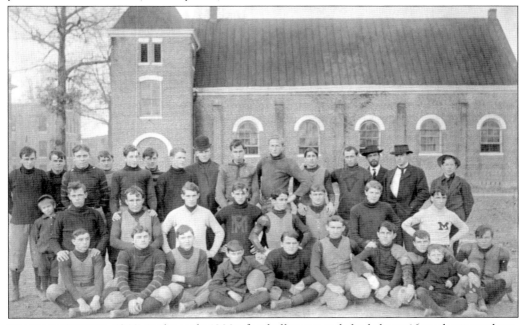

FOOTBALL REUNION, 1910. In the early 1900s, football teams only had about 16 students on them. Posing in front of the Old Gym, these 30 students represent several years' worth of teams. The students in the RM monograms are the 1907 team, those wearing light-colored vests are 1908, and the players in striped sleeves are the squad from 1909.

MARY BRANCH DORMITORY, 1908. Built in 1906, the neoclassical-revival dormitory faced the railroad tracks, and to the right is the Old Gym. The appeal of the dormitory over the cottages was the introduction of steam heat and indoor plumbing in the new building. It was donated by John P. Branch in memory of his wife, Mary Louise Merritt Kerr Branch.

THOMAS BRANCH DORMITORY, 1914. Built in a similar style, the "New Dorm" was also donated by John P. Branch and was named for his father, Thomas. Thomas Branch served as a trustee from 1846 to 1883 and helped purchase the hotel for the new Ashland campus. Both dormitories remain, but in the 2004 restoration, the "U" of Thomas Branch was roofed over to form an atrium and the first floor converted to student services.

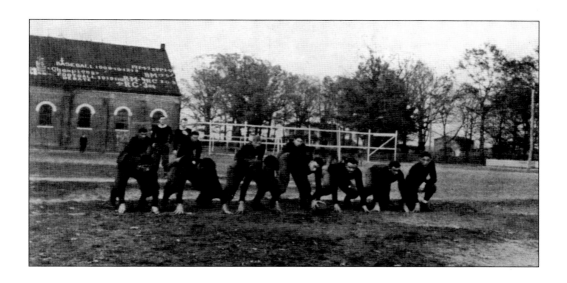

BASEBALL TEAM, 1913, AND FOOTBALL TEAM, 1914. It did not take long for it to become a tradition to write scores on the roof and sides of the Old Gym. Here on the roof, the debate championship joins the athletic teams. The baseball team this year beat VPI, VMI, William and Mary, and Union Theological Seminary. In the fall of 1913, the football team scored 180 points to 126 by their opponents, but that was still a 4-4 win-loss record for the season. The write-up in the yearbook creates an ancient world of Hamsids and Arachnidanuts in faux-Hebrew to describe the games.

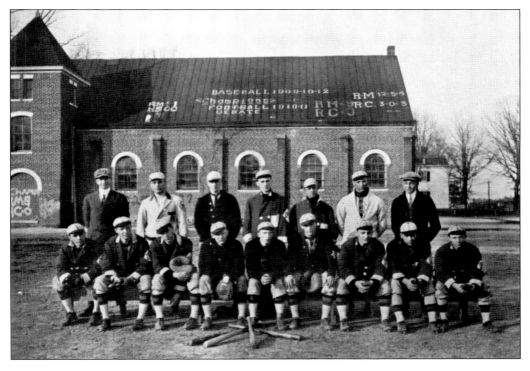

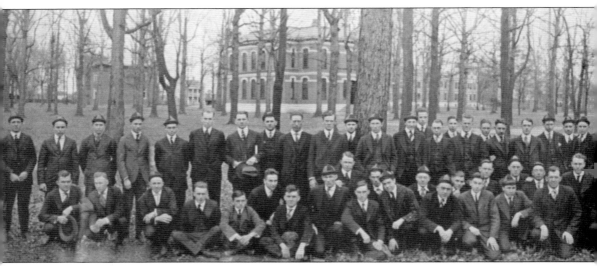

PANORAMA, 1917. A photograph from the 1917 *Yellow Jacket Yearbook* places the student body along the railroad tracks on the west side of campus. The first term began on September 13, 1916; the second term January 3, 1917; and the third on April 10, 1917. Commencement exercises lasted from June 10 through June 14. There were 12 faculty and 177 students. Among the 21 seniors

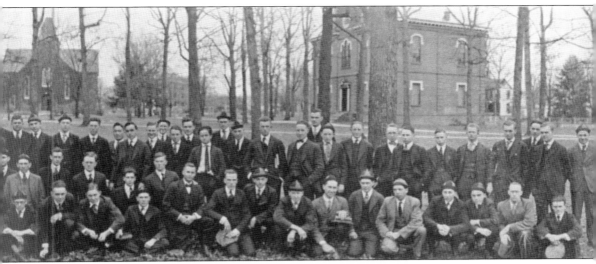

was Yasushi Ibara from Owajima, Japan. There were five fraternities, and the debaters beat both Richmond College and William and Mary. The football team played Hampden-Sydney to a 0-0 tie, but the Yellow Jackets beat the Tigers 20-19 in basketball.

WOODROW WILSON, FEBRUARY 2, 1912. Formed in 1910–1911 with the motto "A Virginian in the White House in 1913," the Woodrow Wilson Club asked Governor Wilson to address students during a 40-minute interruption of his train trip. He posed for this picture with President Blackwell in front of the Henry Clay Inn and was presented with a "fairy tear" cross by treasurer Hatcher for luck in the upcoming election.

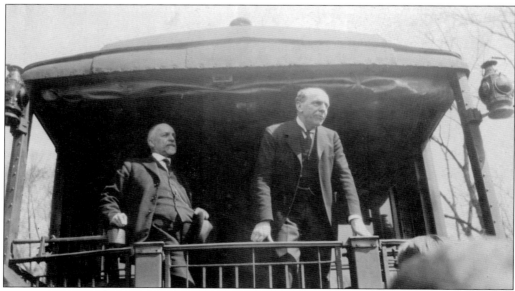

PRESIDENT BLACKWELL AND SECRETARY ROBERT CECIL, APRIL 20, 1923. Another politician on a whistle-stop in Ashland was the former English secretary of foreign affairs, Lord Robert Cecil. Speaking on behalf of the League of Nations, Lord Cecil addressed R-MC students after the faculty canceled a class period. Cecil would win the Nobel Peace Prize in 1937.

CHECKER SHARKS, 1918.
Shelton Short Jr., from
Lawrenceville, Virginia,
kept a scrapbook filled
with photographs of
friends, girlfriends,
and dances during
his college days. A
senior in 1918, he
was in the Franklin
Literary Society, a
member of KA and
BLAKI, and president
of the Cotillion Club.
According to the
senior class notes, "he
sometimes attends
classes, but he does
this merely as a favor to
the professors."

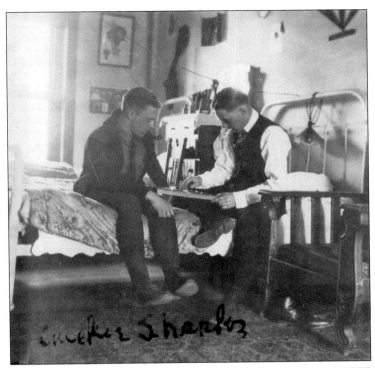

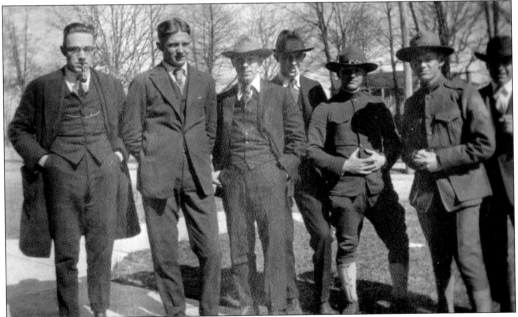

GREAT WAR AT RMC, 1918. Although a senior in 1918, Short did not graduate but joined 17 students and two faculty in Plattsburgh, New York, eight of whom were commissioned as second lieutenants in the U.S. Army. They returned to campus and started the Student Army Training Corps; students drilled for four hours each day. Short did finally attend his commencement exercises in June 1919.

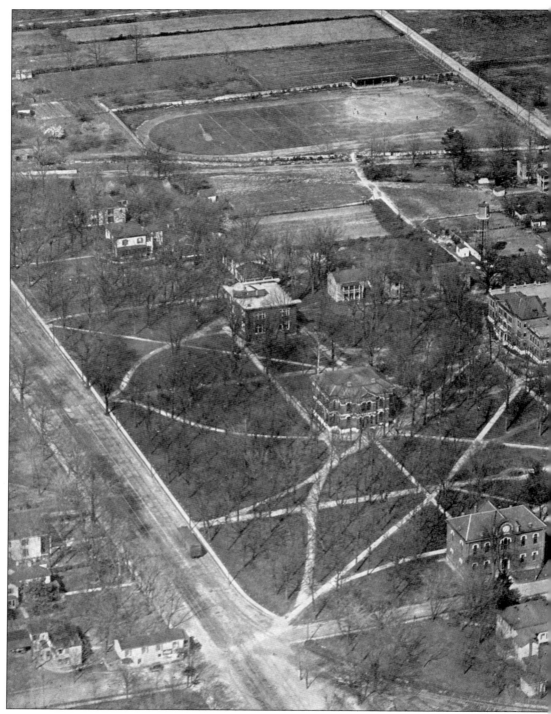

CAMPUS AERIAL, 1922. President Blackwell took advantage of aerial photography for a publicity shot of the campus. From the south, the railroad tracks make a "Y" south of Wash-Frank Hall; the bleachers stand north of the new baseball field where the team is out playing; faculty houses

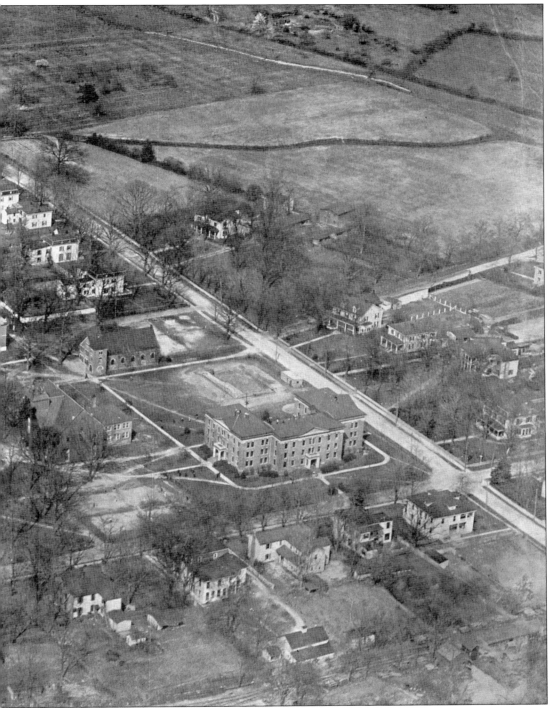

line Henry Street, and the creek flows through what would become the Moreland campus. The farms around the perimeter indicate the preference Blackwell had for a small, rural setting for the college.

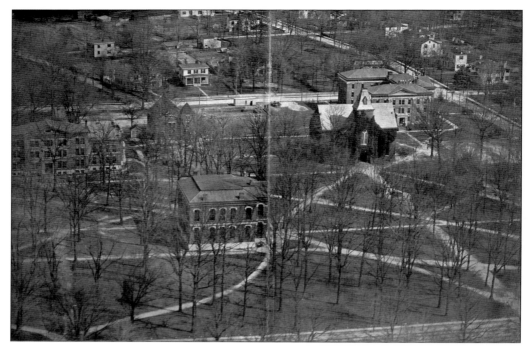

COLLEGE CAMPUS, 1922. As the plane flew northwest, this close-up shows the foundations for the new Carnegie library on the former playing fields next to Old Gym. The plane was being watched by students standing on top of "New Dormitory," as Thomas Branch was called then. To the left of the Old Gym is a shed that once served as a gatehouse, visible in the 1880 view.

PHI BETA KAPPA, 1923. The Delta chapter of Virginia of Phi Beta Kappa was installed May 3, 1923. Alumni, seniors, and faculty were elected members in this first installation. Associate members included residents of Ashland who had been elected in previous institutions, including the librarian Nancy Sydnor. Both Dr. John Fisher, professor of modern languages, and his wife were elected.

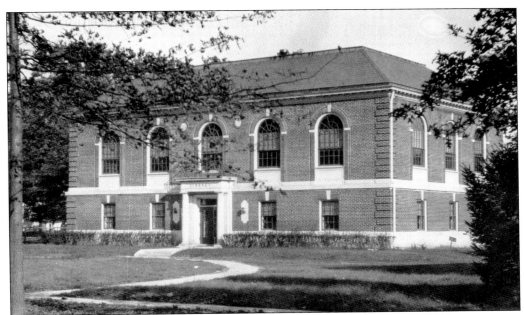

WALTER HINES PAGE LIBRARY, 1923. Named for a 1876 graduate—one of Duncan's recruits stolen from Trinity College who became a publisher and served as ambassador to Great Britain from 1913 to 1918—the Page Library was built with Carnegie funds after great efforts from President Blackwell. There was also a Walter Hines Page Club, part of the Carnegie Foundation for International Peace, for students interested in international relations.

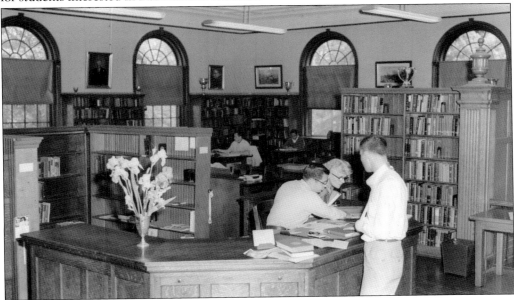

CIRCULATION DESK, 1957. Reader services were located on the second floor of the library, with two floors of stacks and study space. Books were shelved according to Dewey classification, and there was also a music listening room as well as rooms for seminars and debate preparations. In September 1942, Nancy Sydnor Haley retired and Flavia Reed was hired as librarian. She would remain for 42 years.

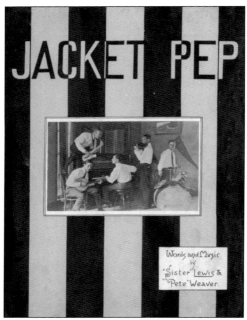

JACKET PEP, 1921. Written by "Sister" Lewis and "Pete" Weaver, the fight song chorus goes: "Old R.M.C., old R.M.C. / We know what you're going to do / Lemon and black, Never comes back / Without a victory / We are for you, All the way through / Jackets will never say die / Give a hip, hip, hooray. We are fighting today / For dear old R.M.C."

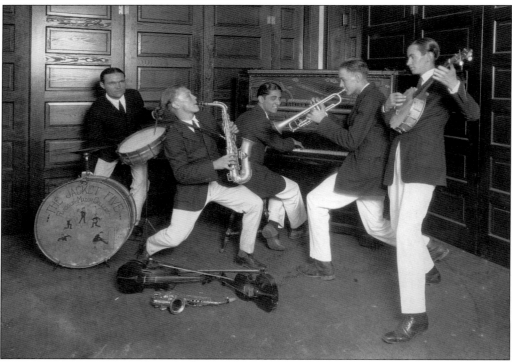

THE JACKET FIVE, 1923. Pete Weaver was also the manager and played the saxophone for The Jacket Five. On the piano is Maurice Michael, whose scrapbook holds the photographs and cotillion programs of the band. Besides The Jacket Five, the R-MC band also played for dances at the Henry Clay Inn. Sponsored by the Hanover Cotillion Club, a campus organization, dance tickets could be bought for $2.

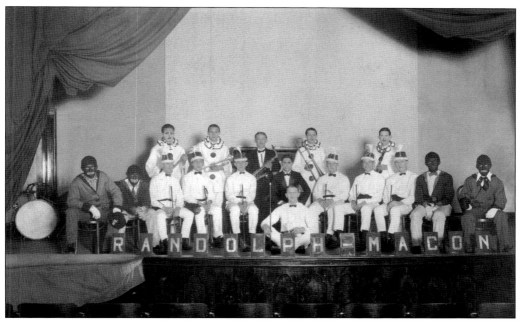

RANDOLPH-MACON GLEE CLUB CONCERT AND MINSTREL SHOW, 1922. Maurice Michael's scrapbook also holds photographs of and programs by the glee club. Performing in a high school auditorium, the orchestra and choir started off with "Jacket Pep." The second part of another show included such minstrel songs as "Mah Punkin Sue."

LEMON AND BLACK, 1938. One of the many pep songs called the school color "lemon," as in "Jacket Pep." Earlier, as reported in the 1893 "R-M Monthly," a discussion during chapel exercises led to the decision to keep the colors already in use—"grasshopper yellow and black." "Our foot-ball and base-ball teams will continue to hop about in those subdued colors." However, lemon and black are the designated school colors today.

LEMON AND BLACK

1

I'm a Yellow Jacket born,
 And a Yellow Jacket bred,
And when I die
 I'll be a Yellow Jacket dead.

CHORUS:

So Ray-Ray for Randolph-Macon,
 Ray-Ray for Randolph-Macon,
Ray-Ray for Randolph
 RAY-RAY-RAY!

2

Lemon and Black
 Will wave on high,
Old R.-M. C.
 Will never die.

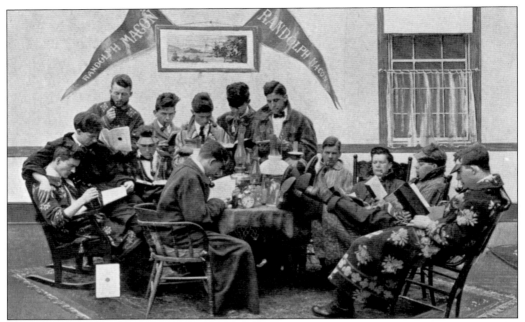

THE OWL CLUB, 1910. Even 100 years ago, students were known to sleep by day and study by night. The Owl Club's members included an owlet who retired by 2:15 a.m., barn owls who retired at 4:20 a.m., and screech owls who retired any time after the last railroad car. Judging by the lamps on the table, burning the midnight oil was literal in those days.

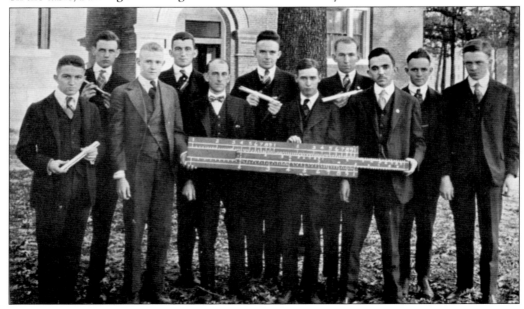

SLIDE RULE SLIDERS, 1917. A club with the latest technology poses in front of Pettyjohn with their slide rulers. They were also known as the "Satellites of Physics II," and student names were aligned with those of the planets (Paul Gravely, Earth)—except Pluto, which was not discovered until 1930 but was then demoted in 2006. So the Satellites do remain astronomically up-to-date in spite of their technology.

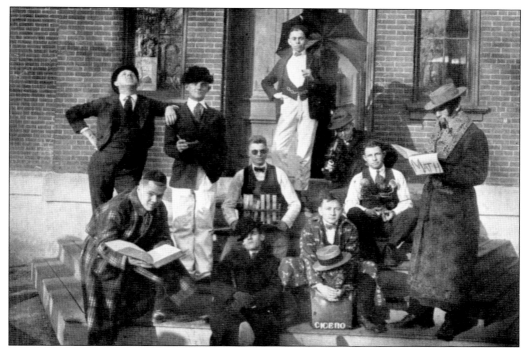

LITTLE FACULTY, 1921. This year, the Little Faculty (student assistants) spoofed their subject specialties and their professors by dressing up and having such monikers as "Eddie" (Dr. Edwin Bowen taught Latin) Jones as Cicero, "Early Lee" (Dr. Fox, History) Leftwich as Historical Star Gazer, and "Potty" (Dr. Thomas Jones, Greek) Tarry as Socrates. George Tarry would return to teach as professor of Bible from 1930 until 1968.

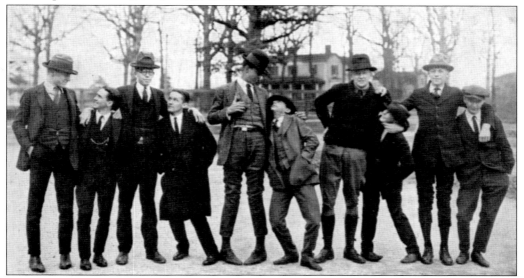

THE MUTT AND JEFF CLUB, 1922. One of the crazier clubs of the 1920s, the Mutt and Jeff Club boasted the pairs "Magnus" Hardy and "Parvus" Robinson, "Grande" Williams and "Pequeño" Thornton, "Vasto" Wilkinson and "Picolo" Jones, "Gros" Hall and "Petit" Smith, and "Grosse" Stuart and "Klein" Robinson.

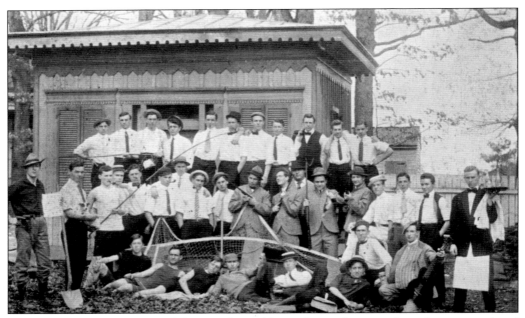

TIDEWATER CLUB, 1909. Many clubs were formed by students who came from the same regional areas or from the system schools: Front Royal Club, Piedmont Club, and House of Hanover, for example. The Tidewater Club poses with its regional paraphernalia, including rifles, pistols, and fishing poles, in front of a distinctive meetinghouse. The club yell included the lines "Jolly, jolly roysters! Fresh fish and oysters!"

SERVANTS QUARTERS, 1932. This building itself remained to be listed in the Fire Insurance Survey of 1932. Located by the railroad tracks, in the backyard of the Vaughan house, it was described as the sleeping quarters of a "negro servant" and partly used for storage. The survey contains valuable descriptions, a map, and photographs of buildings, including corn cribs and woodsheds.

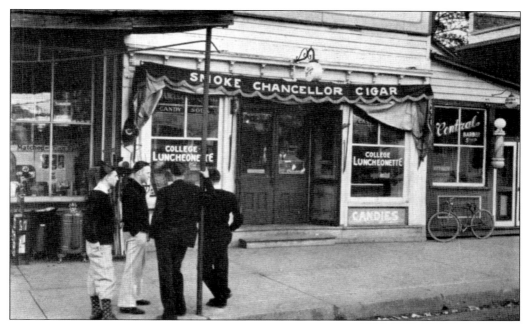

COLLEGE LUNCHEONETTE, 1928. Students patronized shops in downtown Ashland. Freshmen in their beanies stand under the awning at Stebbins Store and gaze at the College Luncheonette offering its cigars. This photograph appeared in the Freshman Class section in the yearbook, along with the Kipling quote "but a good cigar is a smoke."

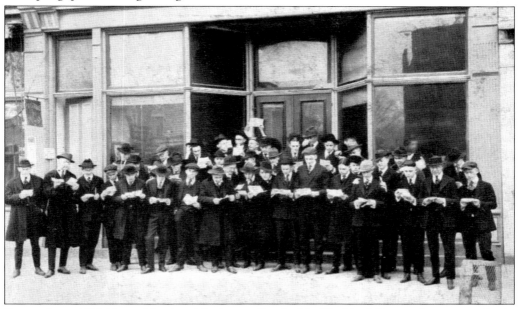

EIGHTY CLUB, 1920. Named for the nighttime mail train, No. 80, this club's members are posing in front of the Ashland Post Office on Center Street. In the 1914 yearbook, the club entry read, "Some expect large epistles from *the fair one*, some checks from 'Father.' Others, bills or advertisements— but all expect." The members included E. P. Barrow, the "Confident"; W. P. Hunnicutt, the "Hopeful"; and M. F. Parker, the "Check Receiver."

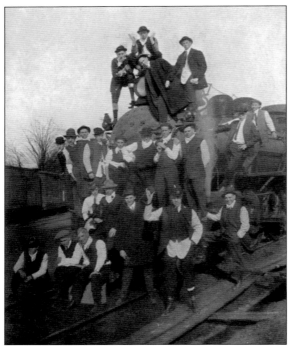

TRACK TEAM, 1914. Falling under the section for clubs rather than athletics, this group posing on a train engine includes Arthur Morton, champion high-chicken-coop hurdler; Marvin Blount, holder of the running boxcar jump record; Robert Dugger, holder of the 50-yard breadline dash record; and Calvert Estill, champion front-doorstep hurdler. Students sometimes jumped on freight cars for a free ride into Richmond.

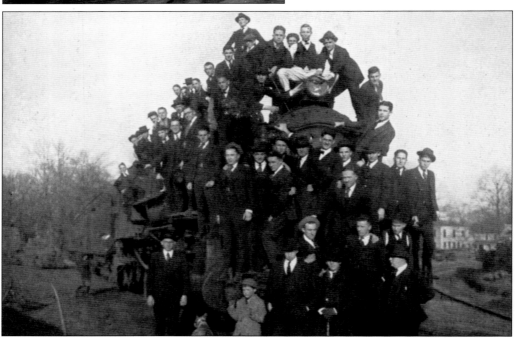

HOBOS' UNION, 1921. This is the "Local Lodge of the Amalgamated Order of Conductor Dodgers and Tie-Walkers." Students coming to R-MC by train continued to have close ties with trains, as this interesting group points out. President Blackwell was the faculty sponsor, but only four students are identified in the 1921 yearbook; as for the rest—"We give it up!" The "Hobo Club" persisted as late as 1946, promoting a "more comfortable mode of dress."

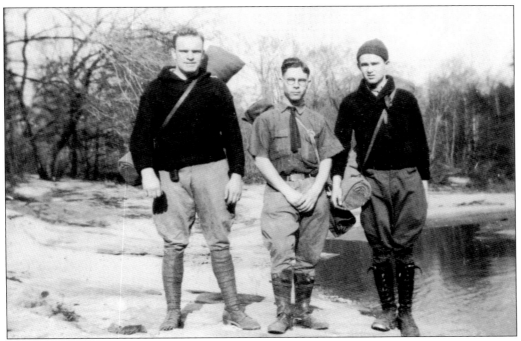

OVERNIGHT HIKE, 1922. From Roscoe C. Johnson's scrapbook, this photograph shows, from left to right, Charles Phillips, George McCary, and Johnson on a hike. Ashland was surrounded by fields and streams and still provides spaces for outdoor activities. The current student group is called Macon Outdoors.

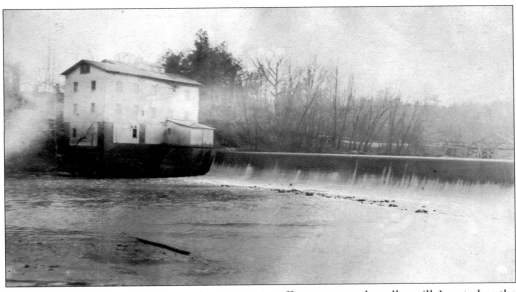

ASHLAND ROLLER MILLS, 1922. A popular spot to visit off campus was the roller mill. Located on the South Anna River, the grain mill on that site was one of Hanover County's oldest, dating from 1807. Rebuilt after a flood in 1889, Newman's Mill and the dam were pictured in many scrapbooks and college viewbooks. Rebuilt again after a fire in 1980, the mill still produces flour and mixes.

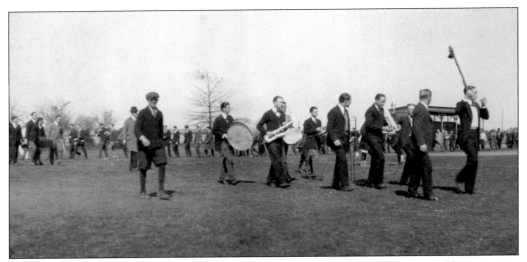

FUNERAL OF "POOR OLD JIM," APRIL 2, 1924. Trying to encourage the college to build a new gym, students held a funeral for the Old Gym. The funeral oration was held in the chapel, and the coffin made a procession through Ashland streets to the athletic fields, where the "body" was lowered into the grave. On April 15, the winning gymnasium plans would be announced.

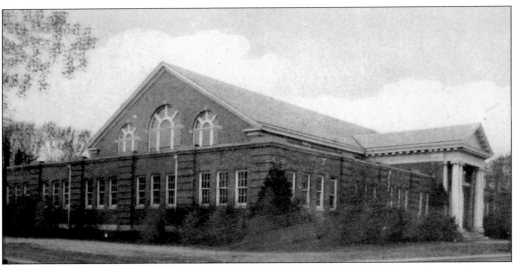

ALUMNI GYM, 1927. No longer happy with the oldest gym in the South, athletic director Gus Welch led the efforts to build a modern gymnasium. Modeled after the gym at St. John's College, Annapolis, the new facility had an indoor, suspended track around a basketball court, and later a swimming pool was added. The building was a gift of the alumni in a time of great interest in athletics.

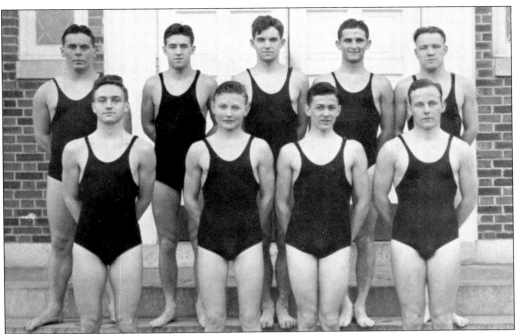

SWIM TEAM, 1933. The college started a swim team when, as a gift from John S. Poindexter, class of 1896, a pool was built in the new gymnasium. In 1933, the team swam against William and Mary and Duke University but lost its meets. Student Rowland Clayton served as coach and instructor in swimming and lifesaving.

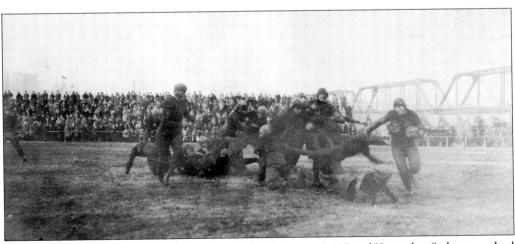

MAYO ISLAND, 1923. In Richmond, the annual clash between R-MC and Hampden-Sydney resulted in a huge loss by the Yellow Jackets, 25-6. After four years with three coaches, the team had played its first year under coach Welch. The *Yellow Jacket Weekly* called for the coach to be reappointed, and Welch continued to hone the bodies of his students by introducing new games and sports to the campus.

COACH GUS WELCH, 1924. "Victory, but by fair play" was Coach Welch's motto. The Native American was a graduate of Carlisle Indian School in Pennsylvania and came to Randolph-Macon from Washington State College. He was interested in the physical training of all students and introduced boxing, track, and lacrosse to the college. He may have also started the first store on campus, the Varsity Shop, which helped support the athletic program. Welch came to Randolph-Macon in 1923, but six years later went to the University of Virginia. He left behind a new gymnasium, new sports teams, and a better financial situation for the athletic board.

POLE VAULTER, 1925. Welch promoted the track team into a major sport in 1924. With a gift of a boxcar full of cinders from the Richmond, Potomac, and Fredericksburg Railroad Company, the track team had a better running track and an improved showing at the meets. In 1926, the Jackets beat the Tigers 9 first places to 6.

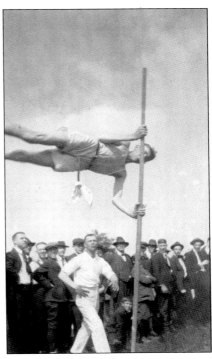

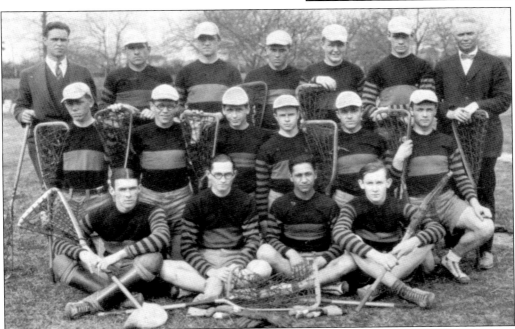

LACROSSE TEAM, 1926. New to the South, lacrosse had to be explained in the 1926 yearbook: "It is played on a field approximately the same size as a football gridiron. Each team consists of twelve men, equipped with sticks loosely strung with rawhide. As we go to press, the first intercollegiate meet in Virginia has been staged, in which Randolph-Macon tied the University of Virginia, 1 to 1."

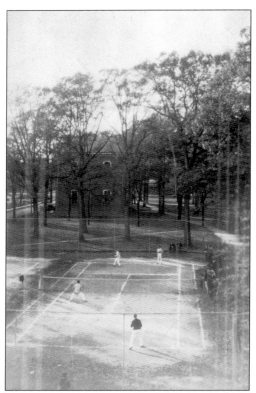

TENNIS TEAM, 1923–1924. Tennis held club status, but the team won against the University of Richmond, although the last set was called on account of darkness. Viewed from Thomas Branch, the tennis courts were located between it and Wash-Frank Hall. The courts can be seen in the 1922 aerial photograph. The most popular sport, in the 1924 yearbook tennis had 70 students playing in fall- and spring-term teams and a faculty advisor, Dr. Edwin Bowen. A member of the class of 1887, Bowen returned to the college in 1894 with a doctorate from Johns Hopkins and taught Latin until he retired in 1950. He was known in Ashland for his daily habits of exercise, bicycling, and playing tennis. When new tennis courts were built in 1951, on the west side of the tracks, they were named in his honor.

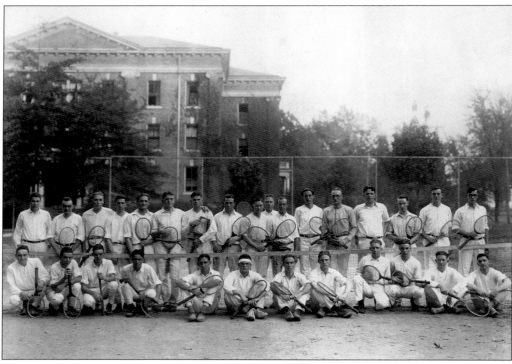

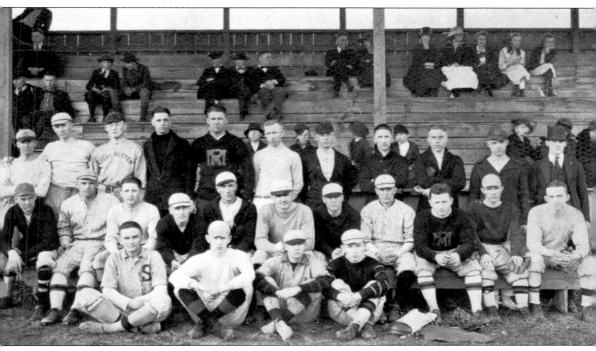

BASEBALL TEAM, 1920. These bleachers are in a baseball field on the north side of campus, where the field moved after Thomas Branch Dormitory was built. Some team members were returning students with experience overseas. Their entry in the 1920 yearbook records, "Captain [Linwood] Butterworth is in uniform again after spending two winters chasing submarines for Uncle Sam. 'Butter' is a reliable man behind the bat and in the infield and is a mighty wielder of the willow. "Manager [David] Mays piloted an A.E.F. team in Germany, France, Belgium and Luxemburg." Willis Lipscomb played football and basketball as well as baseball. Their opponents included Virginia Polytechnic Institute (VPI) as well as the usual Richmond College, William and Mary, and Hampden-Sydney.

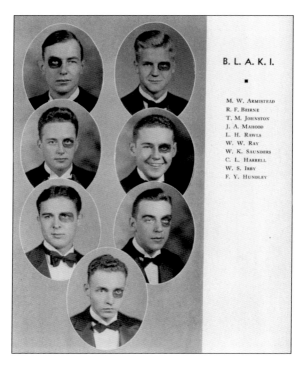

B. L. A. K. I.

■

M. W. ARMISTEAD
R. F. BEIRNE
T. M. JOHNSTON
J. A. MAHOOD
L. H. RAWLS
W. W. RAY
W. K. SAUNDERS
C. L. HARRELL
W. S. IRBY
F. Y. HUNDLEY

BLAKI, 1936. Various student organizations appeared through the years, but perhaps none so bizarre as the "Black Eye." J. Rives Child, class of 1912, was among its founders in 1908, and the club persisted for many years. The distinguishing black eye remains of unknown origin, but the members met at the Henry Clay Inn to "discuss current events" (for amusement). The initials supposedly stand for "Be Loyal Always Kindred Institutions."

DRAMATIC CLUB, 1929. Grellet Collins Simpson was president of the dramatic club, and stuck into his 1929 *Yellow Jacket Yearbook* is a photograph of one of the productions. The yearbook only lists officers and members, not the productions, but another club was the Randolph-Macon Players who presented *The Importance of Being Earnest* with an all-male cast.

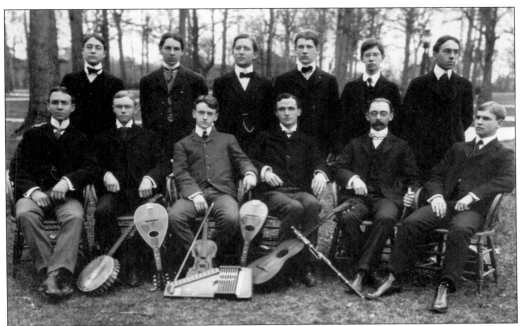

GLEE CLUB, 1901 AND 1966. The Randolph-Macon College Glee Club has a long and strong tradition at the college. Other club photographs show students with instruments, but the glee club members played violins, mandolins, Autoharps, guitars, banjos, and flutes. Vocals consisted of tenors and basses, and the group divided into orchestra, quartet, and chorus. The church choir included three local girls. The glee club or Randolph-Macon College Choir continues at the school. Performing, touring, or recording, the members may have different repertoire, and the male chorus may now be mixed, but a strong choral tradition continues.

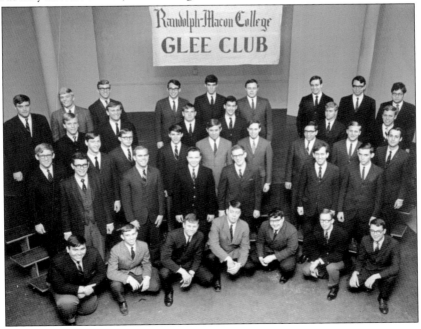

W. B. SAUNDERS

J. W. SMITH

N. T. HEPBURN

F. O. SMITH

H. F. McCABE

T. McN. SIMPSON

J. R. LAUGHTON

J. F. PEAKE

T. H. PHELPS

H. P. SANDERS

NORVAL HEPBURN, 1901. Norval Hepburn, class of 1901, was a founding member of the historical society and published in the *Monthly* the letters of his ancestor Leven Powell, a key figure in Revolutionary Virginia. Hepburn played fullback on the football team and was assistant business manager of the school newspaper. His class prophecy foretold his future career: "After many years shall have passed this man shall graduate in medicine."

PRES. BLACKWELL WITH KATHERINE HEPBURN, FEBRUARY 3, 1938. Dr. Norval Hepburn and his wife visited the R-MC campus with their daughter Katherine. Escorted by President Blackwell, they strolled for more than an hour before being spotted by students. Hepburn had to retreat to Wash-Frank Hall, but she did pose for a photograph. She had just finished filming *Bringing Up Baby* with Cary Grant.

GOLF TEAM, 1934. Announced in the 1934 yearbook, "Another new sport has come to Randolph-Macon—golf! Considering that it was their first year, the players did exceedingly well. As none of them had played tournament golf before, they were decidedly handicapped. Much credit goes to Dr. Day, Dr. Smith, and Coach Shepard for their interest in the team." The team played the University of Richmond, Catholic University, William and Mary, and the Westwood Golf Club.

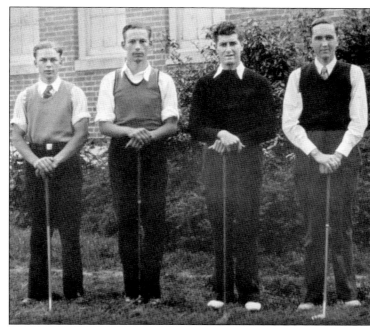

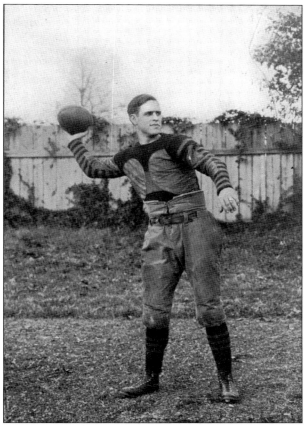

"THE ATHLETE," 1925. Kenneth Crouse, captain-elect of the 1925 football team, was chosen to represent one of six "Types of College Men." A punter, passer, and runner, Kenny was also president of his class for three years, including his senior year. Other types were "Student" (Onyx Bennett), "Minister" (Archie Acey), "Man of Affairs" (Charles Hales), "Merry Maker" (Pete Weaver), and "Society Leader" (Alton Crowell).

81

"MODERN MAN," 1926. The yearbook had a feature series titled "The Ages of Man," with students portraying Man as Ape, Missing Link, Cave, Pre-historic, Roman, Elizabethan, Colonial, and Modern. The students are not identified, but the man here resembles Kenneth Crouse in his senior year. The house is definitely not in Ashland. Crouse, described as "the most popular man on the campus for four years," was from New York City.

Four

MORELAND ERA
1938–1967

PRESIDENT J. EARL MORELAND, 1939–1967. Former president of Porto Allegre College in Brazil, Moreland kept the men's college running through World War II and the Korean Conflict. He strengthened the liberal arts curriculum with new departments of economics, fine arts, German, philosophy, political science, and psychology. He transformed the campus with the addition of Fox, Haley, and Smithey Halls; Blackwell Auditorium; Page Library; faculty housing; and motel-style dormitories.

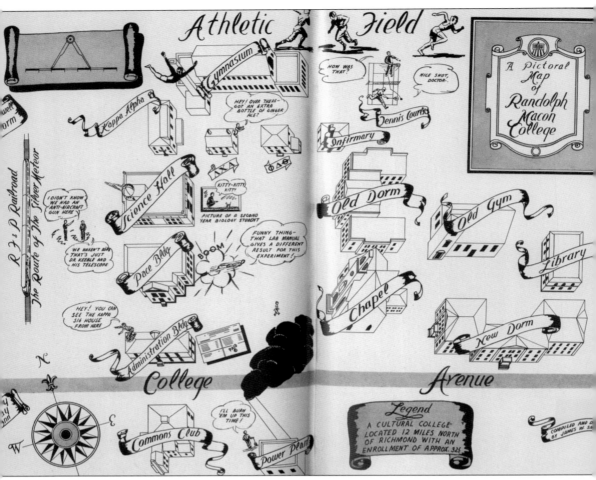

Pictorial Map, 1941. Drawn by student James Smith, this map notes the Richmond, Fredericksburg, and Potomac Railroad, Library, Science Hall, both the Old Gym and the new, and the Administration Building. The two branch dormitories are "Old" and "New" Dorms, while the infirmary and tennis courts will soon give way to the new Campus Exchange. Various comments give a voice to the 325 students then on campus.

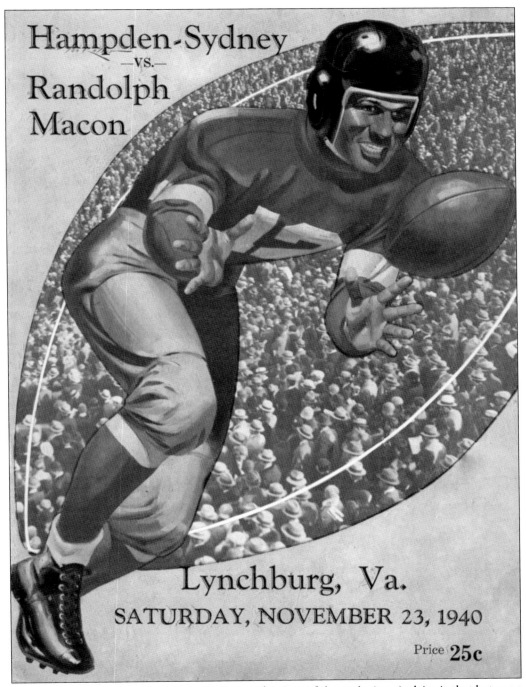

Hampden-Sydney
—vs.—
Randolph
Macon

Lynchburg, Va.
SATURDAY, NOVEMBER 23, 1940

Price 25c

HAMPDEN-SYDNEY VERSUS RANDOLPH-MACON, 1940. One of the enduring rivalries is that between Randolph-Macon and Hampden-Sydney College in Farmville. Around 1879, football became popular, and by 1893 a schedule of games brought the frenzy that would lead to challenges of the present Hampden-Sydney Game Week, with its blood drives and other student activities leading up to the big game. Unfortunately, at this meeting the H-SC Tigers won, 27-7.

ARMY BAND, 1946. During 1943–1944, the Army Specialist Training Program (ASTP) was attended by 438 soldiers, supplementing the remaining 83 students. ASTP lived on in Ashland memory, as President Moreland remembered that 56 Ashland girls found their husbands among the cadets. Unfortunately, the program moved to Pennsylvania in 1944, and the college had only 99 students, among them 18 local women. But thanks to the GI Bill, the men returned to college.

MOTEL DORM, 1962. To house the returning veterans (and their families), Veterans Village was built on the north side of campus. In the midst of temporary housing, a new type of dormitory was started. Based on the popular motel accommodations along Route 1, Irby Hall was built in 1953 and was soon followed by more dorms, including apartment-style housing for families. The motel dorms later became the remodeled Freshman Village.

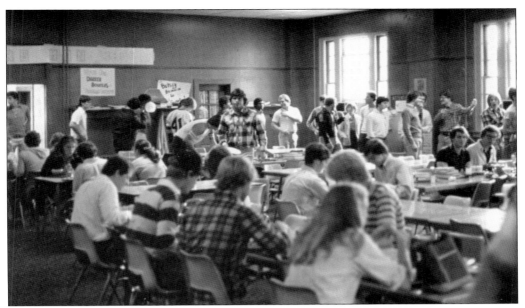

DINING HALL, 1960s. A small brick building next to Alumni Gym was constructed in 1946 as the new dining hall on campus. Earlier, students had to eat in Ashland boardinghouses. In the 1933 *Fishtales*, ads would read, "Table Board Available at Mrs. Ragland's and Mrs. William's." At last a campus facility let students dine on campus. The building still exists, but it now houses the weight rooms, equipment, and offices of the athletic teams.

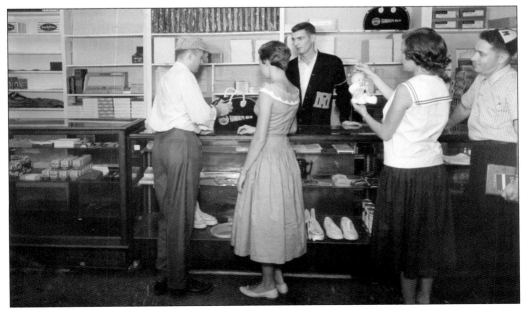

CAMPUS EXCHANGE, 1957. Built in 1947, the Campus Exchange contained a bookstore, souvenirs, and a soda fountain. Randolph-Macon dolls are on sale for the years 1957—1960. Before the exchange was built, the bookstore was located in the Administration Building (Wash-Frank Hall). The exchange was torn down when Brown Campus Center went up in 1974.

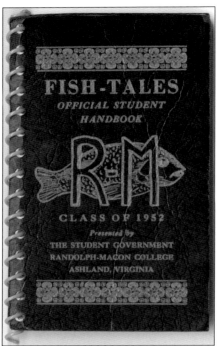

FISHTALES, 1948–1949. Freshmen in the class of 1952 received a copy of the *Student Government Handbook* when they came to campus. Freshmen had been called fish since at least 1899, when the first yearbook mentioned "big fish, little fish, and a few minnows" coming in September. Inside was information on the honor code, activities on campus, athletic schedules, and a section on "How to Study."

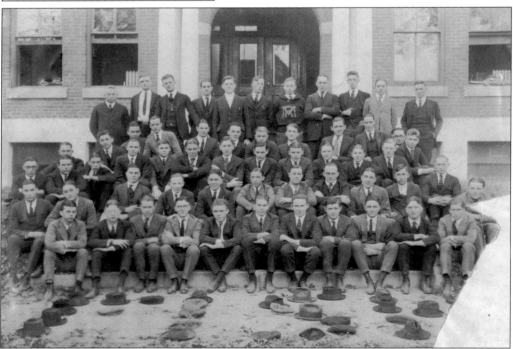

FRESHMAN CLASS, 1922. Spelling out their status as "FISH" with their hats, the gentlemen pose for their yearbook portrait. This photograph was not used in the yearbook but was put in the scrapbook kept by the freshman class president, Roscoe Chesterman Johnson. Johnson graduated in 1925, became a Methodist pastor in 1927, and served for 46 years.

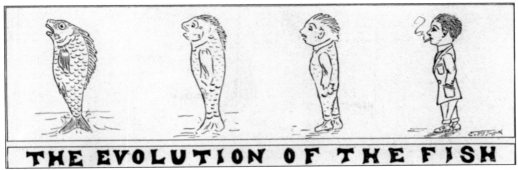

THE EVOLUTION OF THE FISH

THE EVOLUTION OF THE FISH, 1909. The "History of the Class of 1912" in the 1909 yearbook speaks of members' first year at college: alighting from trains, coming up out of the sea, and talk of whales and minnows on campus. There was dancing and singing at first but then settling down to work at the thought of their duty "to our parents, our professors, and ourselves."

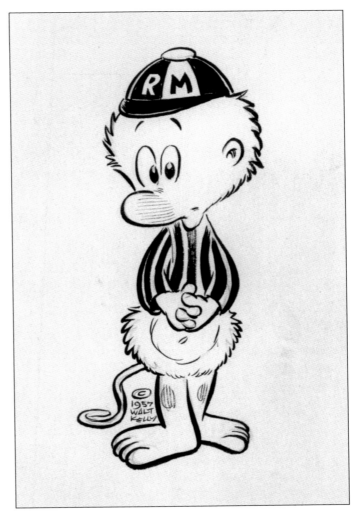

POGO, 1957. One year, student editor Tom Inge persuaded cartoonists to send drawings for *Fishtales*. Walt Kelly graciously sent Pogo, wearing a freshman R-M beanie, for the front cover. *Fishtales* is still the name of the student handbook issued by the Dean of Students Office each fall, but beginning in Fall 2010, it is published only online.

HAZING, 1926. A posed photograph from Perkins's scrapbook complements the text from freshmen class histories in the yearbooks. Being paddled and making paddles for the next year's "Fish" are always mentioned. "We think we are sufficiently able to undertake the delicate task of bringing up the next year's 'Fish.'" Even much later, there were fish raids, which led to push-ups, marches, and college spirit songs.

PAJAMA PARADE, 1941. One tradition that seems less violent was the pajama parade. For many years, the night before homecoming, freshmen in their pajamas were marched by torchlight through the streets of Ashland before coming back to guard their wood for the bonfire from upperclassmen or opposing schools. Even in 1963, the pajama parade continued, but the pile of wood had become a cage.

FRESHMEN WITH CAGE, 1963. Still wearing their beanies, freshmen carry their cage to the pep rally. On the Thursday night before homecoming, 100 "Fish" defended their cage by hoisting it up a tree and smearing the trunk with motor oil. Forty upperclassmen could not wrestle it away and embarrass the Fish by burning the cage prematurely. Homecoming saw R-MC victorious over Johns Hopkins, 18-0.

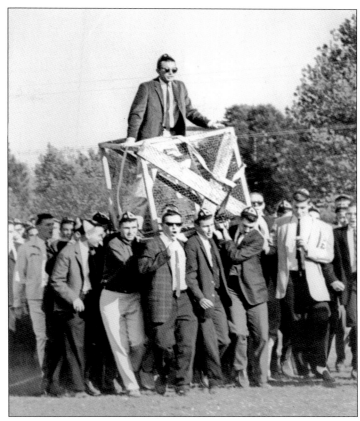

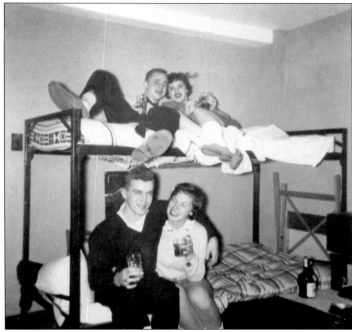

FEATURES SECTION, 1956. Many photographs must be scanned from old yearbooks, because original photographs were sent to the printers. Robert Doggett, coeditor-in-chief of the 1956 *Yellow Jacket*, did preserve five mock-up pages from the 1956 yearbook. Incensed by the excision of six pages in the Features section, he kept the photographs of girls in the men's rooms that had led the deans to razor out the offending pages.

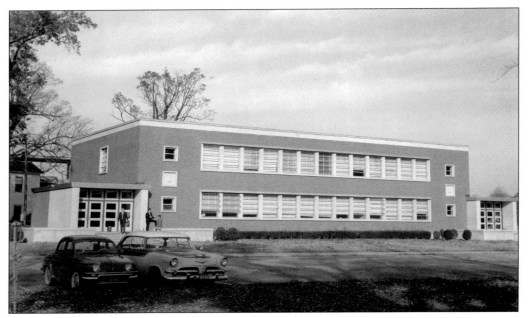

Fox Hall, 1951. Built along Caroline Street with money given by the Methodist Church in its 1944 "Crusade for Christ" campaign, Fox Hall brought its distinctive architecture to house the disciplines of history, philosophy, religion, and social sciences. Trees were later planted to shade its southern exposure. It was named for Early Lee Fox, class of 1909 and Vaughan, professor of history and political science from 1918 to 1946.

Smithey Hall, 1952. Farther down Caroline Street, Smithey Hall was built to house the mathematics and physics faculty, relieving the pressure in Pace (biology) and Pettyjohn (chemistry). It was named for professor of mathematics Royall Bascom Smithey, class of 1876, who taught from 1877 until he retired in 1917. The structure was integrated into Copley Science Building in 1972.

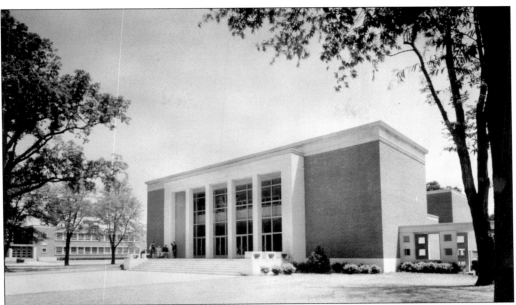

BLACKWELL AUDITORIUM, 1953. Facing the Carnegie library, the new auditorium was named to honor President Blackwell. President Moreland considered it the "representative building" of the campus, succeeding Old Chapel. The entire student body, over 600 at that time, fit then in the auditorium for required chapel; but at 1,200 students, it certainly does not today. The auditorium is used for both town and gown events today.

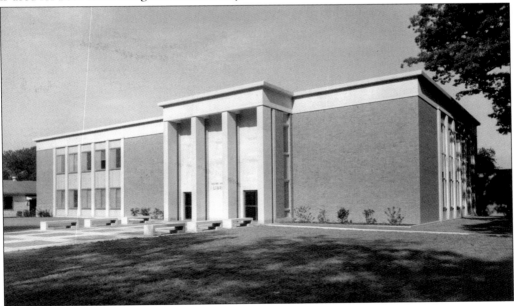

WALTER HINES PAGE LIBRARY, 1961. Built later than the previous three buildings, the new library shared their modern style. The Carnegie building was repurposed for administration, and the library moved down the street. In 1987, it was enlarged and renamed McGraw-Page Library, in honor of the publisher Donald McGraw. The collection was reclassified from Dewey to Library of Congress beginning in 1987, and in 1995 the catalog was automated.

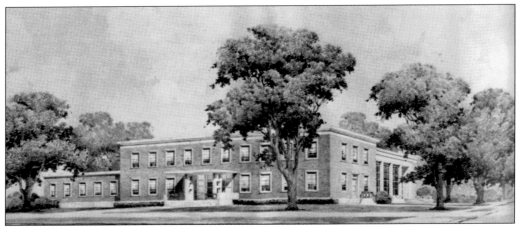

PROPOSED ADMINISTRATION BUILDING, 1955. Opportunity no. 1 in the 125th Anniversary Development Program was the Peele Administration Building. After Wash-Frank Hall was condemned in 1952, administrative offices were moved into the basement of Mary Branch. The proposed new building would be located next to Blackwell Auditorium. But instead, the library moved into a new building, and the old Carnegie library was remodeled for administration.

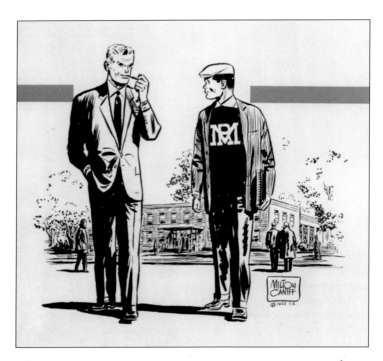

STEVE CANYON, 1958. Administration moved across Henry Street into Peele Hall, renamed for Bishop William Peele. Only a ghost of the proposed building remains in the background of a cartoon solicited by student editor Tom Inge from Milton Caniff for the 1958 yearbook. Meant to be a glimpse into the future for future alumni, it instead is a glimpse into a past campaign.

DUNCAN MEMORIAL CHURCH, NOVEMBER 12, 1955. The Duncan Memorial Church Junior Choir leads the procession to the new church on Henry Street. The old church, which had once held both the Ashland Methodist Church and the college chapel, became the Old Chapel. Dick Gillis, alumnus, Sunday school superintendent, and later mayor of Ashland, watches at far right.

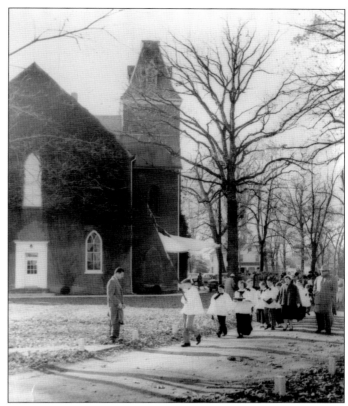

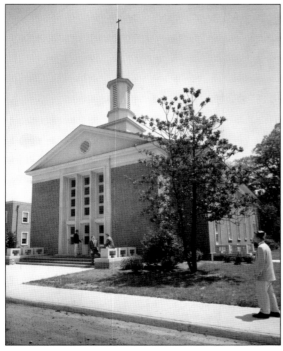

DUNCAN MEMORIAL CHURCH, 1955. The new church still serves the college as well as the Ashland community. The sanctuary building was financed by the Virginia Conference, while the Sunday school building was constructed by the local congregation. Students use the church for services, and many service organizations host dinners in the fellowship hall to raise money for charity.

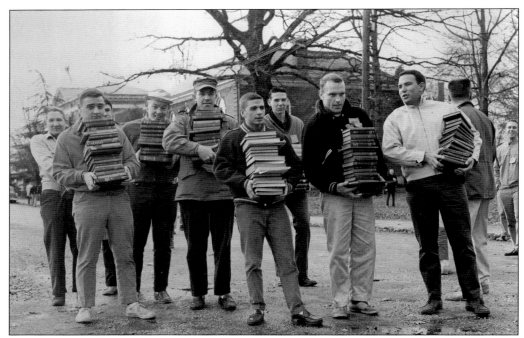

ON THE MOVE, 1961. Students were on the move in 1961. Above, students help transfer books from the Carnegie library to the new Page Library. Having both buildings located on Henry Street made it easier for faculty and students to move the collection in one day. Below, freshmen move into their dorms. Admissions accepted 223 students out of 1,008 applications in 1960–1961, and the total enrollment was 669. Forty-seven faculty and 27 buildings supported the educational experience of these incoming freshmen. The completion of the $7 million Campaign for Christian Higher Education in the Virginia Conference would build Haley Hall, Crenshaw Gym, and Mullen Drive faculty housing.

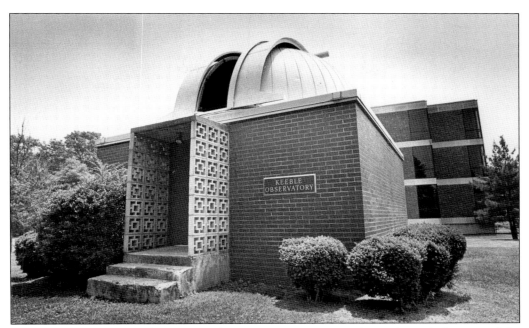

KEEBLE OBSERVATORY, 1984. Built in 1962, a new observatory was located in a darker part of the campus, as town lights and rail traffic increased near Pettyjohn Hall. The dome was built to house a 12-inch Cassegrain reflector and is instrumental in the college's astrophysics minor. Dr. William Keeble was professor of physics from 1919 to 1952. Staffed by student assistants, the observatory is open to the public. (Courtesy of the R-MC Marketing Office.)

MULLEN DRIVE FACULTY HOUSES, 1963–1964. Following a long tradition of supplying faculty with housing, beginning in Boydton and continuing with the cottages in Ashland, the college built six ranch-style brick residences along Mullen Drive. The houses were sold in the 1970s but were bought again and are now used for faculty and staff housing. On the west side of the tracks, they sit between woods and playing fields.

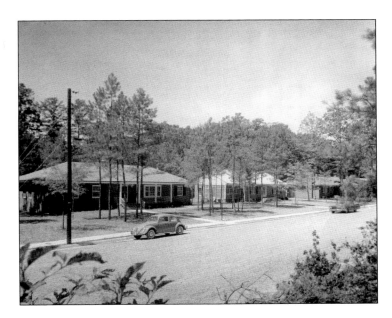

IBM 1620 Digital Computer, Fall 1963. After administrative offices moved into Peele Hall, a computer moved into the basement of Mary Branch Dormitory. With its punch card input and output, the computer was expected to aid students with more complicated computations in their senior projects and honors programs. Dr. Richard E. Grove, director of the Computer Center, started the Computer Science Department in 1966.

WRMB, 1963. Established in 1956, the R-MC radio station broadcast at 635 kilocycles on AM radio. Students handled all operations: announcing, news editing, engineering, and programming, providing training for further work in communications. Here "Sonny Tongue spins a turn table," according to the 1963 yearbook. Music programs specialized in popular (Vic Damone and Dean Martin), folk, jazz, classical, and mood music from 11:00 p.m. to 1:00 a.m.

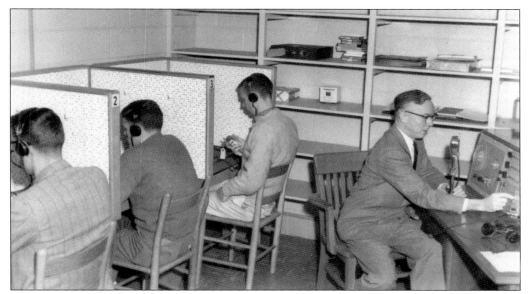

LANGUAGE LAB, 1959. Pictured in the language lab initially installed in 1959 in Fox Hall is John G. Roberts, professor of romance languages. With a master console and five listening booths, the lab offered students the ability to either record their own exercises or listen to "passages from great literature declaimed by a native speaker."

HALEY HALL, 1966. Named for the first chair of the language and literature division in the college, Haley Hall was dedicated in 1966 and contained the "state's newest modern language laboratory" for Spanish, French, and German. Prof. Joseph Haley came in 1921 to teach Greek and German, married the Carnegie librarian Nancy Sydnor in 1925, and taught until his death in 1957.

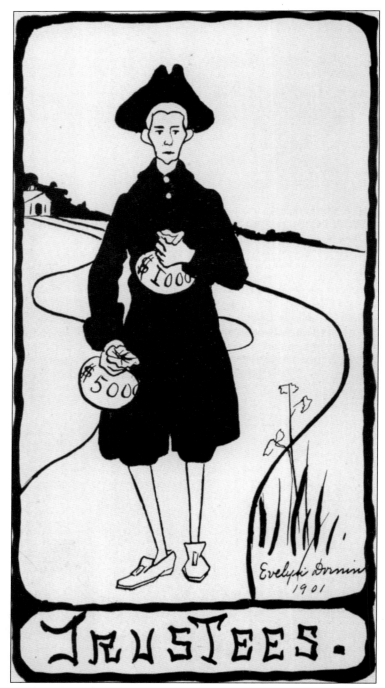

TRUSTEES, 1901. The role and composition of the board of trustees is reflected in this yearbook drawing by Evelyn Dornin. Holding the purse strings of the college, Methodist ministers comprised 22 of the 43 members of the board in 1901. The oldest serving board member was Richard Irby, the first college historian, who was elected in 1854. John P. Branch was elected in 1883 and later donated two dormitories to the Ashland campus.

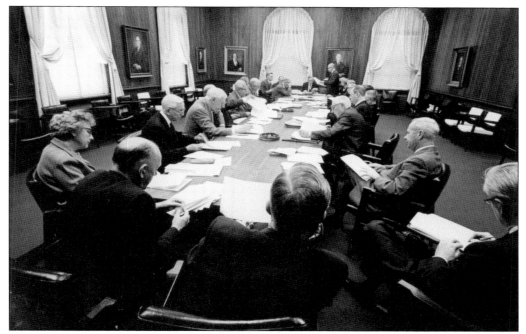

BOARD OF TRUSTEES, 1967. Meeting in the boardroom named for James Mullen, class of 1896 and member of the board from 1955 to 1964, trustees remain responsible for the college. Surrounded by portraits of past presidents and board members, deliberations for the future take place in the context of the past. Seated on the far left is Harriet Fitzgerald, a graduate of RMWC, who served from 1929 to 1970.

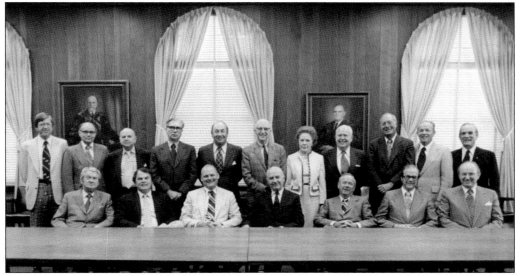

BOARD OF TRUSTEES, 1976–1977. Board members in the photograph include, from left to right, (first row) Roy Davis, Edward Stiles, John Werner, Willis Lipscomb (president), James Butler, John Russell, and Rev. James Turner; (second row) Hunter Jones, Rev. Bernard Via, Amb. J. Rives Childs, Rev. William Wright, James McLemore, Walter Craigie, Margaret Marks, Lewis Ames, James Morriss, Edwin Estes, and Rev. Purnell Bailey.

1830 — *The Oldest Methodist Related College In America* — 1966

Vol. 52, No. 1 THE YELLOW JACKET, RANDOLPH-MACON COLLEGE Friday, September 16, 1966

Tiny Freshman Class Enrolls; Virginia Union Student Accepted

by
John D. Williams

Once again the beanied wonders invade the Randolph-Macon campus for the fall academic session. Although the freshmen will still be seen traveling en masse under the oaks and maples, their number will be considerably smaller than in the past. The class of 1970 will consist of 162 members, or less than half of last year's class. There will also be 37 transfer students from some twenty colleges and universities, including four women students who have, in recent years become a welcome addition on the Randolph-Macon

students is the first Negro student in the college's 136-year history. He is Haywood A. Payne, Jr., a transfer scholar from Virginia Union University in Richmond.

Total Enrollment

The total enrollment for the fall semester is 803, about 15 less than this time last year. How there can be almost the same number of total students as last year might be attributed to better grades on the part of returning students and in-

creased pressure from the big grader in Washington. The few who did not return were as Registrar C. Edwin Cox explained, ". . . students whom we had not expected to be called."

The smaller Freshman Class has already endeared itself in the hearts of the college community. The return of smaller classes and the apparent lack of crowded living conditions seem to many to be at

(Continued on page 6)

Dean Advanced To Veep As Faculty Is Rearranged

A FAMILAR SCENE in front of Blackwell Auditorium as members of this year's Freshman class enter one of

VIRGINIA UNION STUDENT ACCEPTED, 1966. The headline of the *Yellow Jacket* announced the admission of Haywood A. Payne Jr., a transfer student from Virginia Union University, a historically black university. Thus, segregation ended after 136 years. Payne received a bachelor of science degree in 1968 and served on the board of trustees from 1988 to 1999.

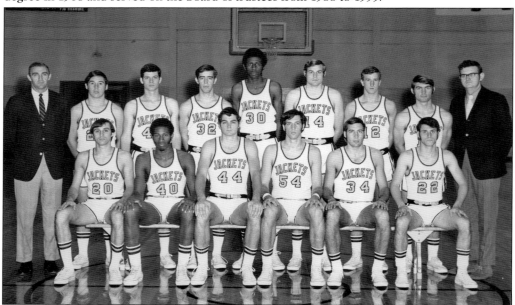

BASKETBALL TEAM, 1970–1971. Coach Paul Webb (on the left) took his team to the Mason-Dixon Tournament that year and eliminated the Hampden-Sydney Tigers 81-68 in the first round. No. 40 is Dennis Howard, who in his senior year in 1972 was captain of the team and president of the student government association. Howard was the first African American four-year graduate of Randolph-Macon College.

MUHAMMAD ALI, 1969. On April 18, 1969, Muhammad Ali (center) spoke to about 1,000 people in Crenshaw Gym. The *Yellow Jacket*, referring to him both as Cassius Clay and Ali (he had changed his name in 1964), reported his coming home from Italy with an Olympic gold medal yet not being able to buy a hamburger in his Kentucky hometown. In the afternoon, Ali met with students in the cafeteria.

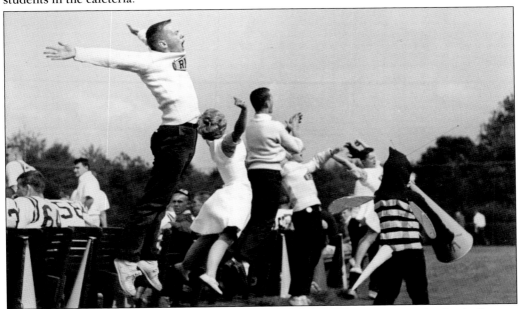

CHEERLEADERS, 1963. Led by the Yellow Jacket mascot, cheerleaders spur on the football team. They led cheers, fight songs, and yells at pep rallies on the steps of Blackwell Auditorium and on the field. The legendary coaches of 1963 were Joseph McKutcheon for football, Paul Webb for basketball, Helmut Werner for soccer and tennis, Ted Keller for track, and Hugh Stephens, director of athletics, for baseball.

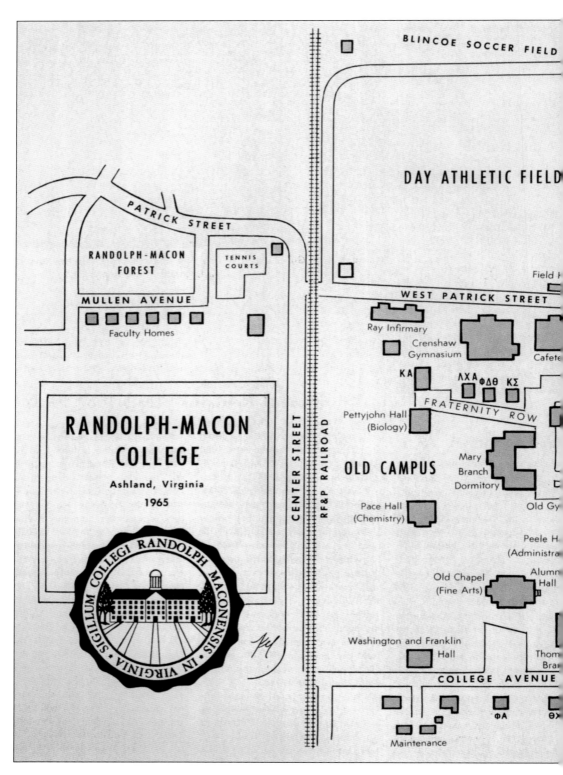

BLINCOE SOCCER FIELD

DAY ATHLETIC FIELD

PATRICK STREET

RANDOLPH-MACON
FOREST

TENNIS
COURTS

MULLEN AVENUE

Faculty Homes

Field H

WEST PATRICK STREET

Ray Infirmary

Crenshaw
Gymnasium

Cafete

RANDOLPH-MACON
COLLEGE

Ashland, Virginia

1965

KA

ΛΧΑ ΦΔΘ ΚΣ

FRATERNITY ROW

Pettyjohn Hall
(Biology)

OLD CAMPUS

Mary
Branch
Dormitory

Pace Hall
(Chemistry)

Old Gy

Peele H
(Administra

Old Chapel
(Fine Arts)

Alumn
Hall

Washington and Franklin
Hall

Thom
Bra

COLLEGE AVENUE

ΦΑ

ΘΧ

Maintenance

CENTER STREET

RF&P RAILROAD

SIGILLUM COLLEGI RANDOLPH MACONENSIS · IN VIRGINIA ·

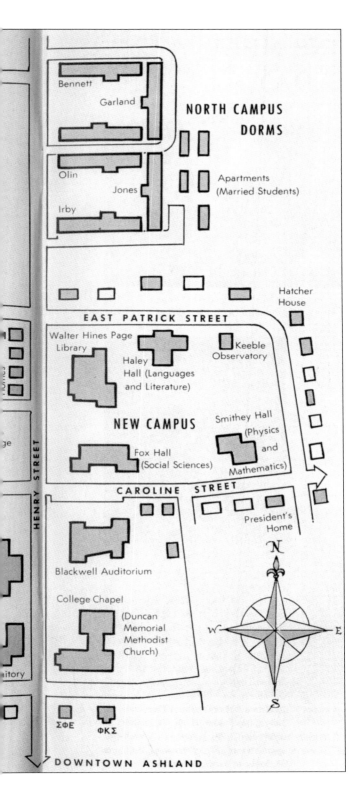

Bennett

Garland

NORTH CAMPUS
DORMS

Olin

Jones

Irby

Apartments
(Married Students)

Hatcher
House

EAST PATRICK STREET

Walter Hines Page
Library

Haley
Hall (Languages
and Literature)

Keeble
Observatory

NEW CAMPUS

Smithey Hall
(Physics
and
Mathematics)

Fox Hall
(Social Sciences)

CAROLINE STREET

President's
Home

Blackwell Auditorium

College Chapel

(Duncan
Memorial
Methodist
Church)

N

W E

S

ΣΦΕ ΦΚΣ

DOWNTOWN ASHLAND

HENRY STREET

CAMPUS MAP, 1965. Witness to the building fervor of Moreland, the campus still retained Pettyjohn Hall, the Campus Exchange, and Old Gym. Mullen Drive was a through street, and Fraternity Row was linked by roadway to Henry Street. Estes, Brown, the Fountain Plaza, Brock Center, and Copley were yet to be, while the Randolph-Macon Forest would become playing fields as the college expanded west of the railroad tracks.

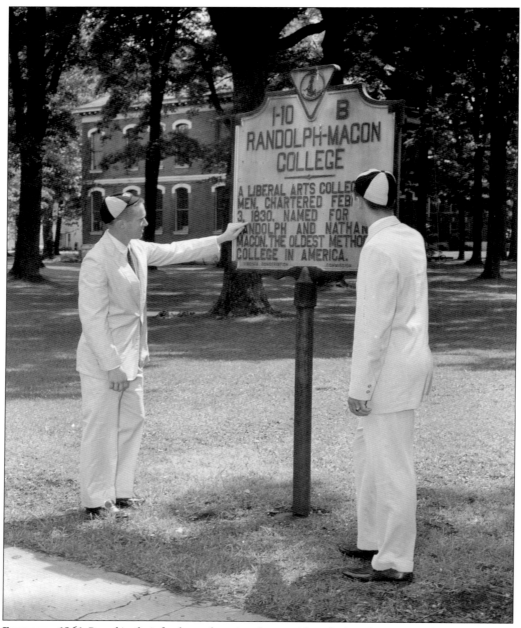

FRESHMEN, 1961. Posed in their freshmen beanies, these unidentified students were photographed for an article on admissions and enrollment in the *Alumni Bulletin* of April 1961. The historical marker describes "a liberal arts college for men." That description would soon need to be changed.

Five

MODERN ERA
1967–PRESENT

LUTHER W. WHITE III, 1967–1979.
The 12th president of the college
was Luther White, class of 1947.
Previously an attorney and former
president of the Alumni Society, White
served during the times of national
campus unrest. In 1971, women were
admitted as residential students, and
during White's presidency, Fountain
Plaza, Copley Science Building, Brown
Campus Center, and Conrad and
Moreland dormitories were built.

BETTY JEAN SEYMOUR, ASSISTANT DEAN OF STUDENTS, 1973. In 1971, women were allowed to reside on campus. Hired that same year as a visiting instructor in religious studies, "BJ" was neither Methodist nor male. She served as assistant dean from 1972 to 1976, but then returned to the classroom. Seymour retired 30 years later, the first woman to earn tenure, chair a department, and achieve the rank of full professor at Randolph-Macon.

ZETA TAU ALPHA, 1978. Women soon created similar clubs and organizations to those that the men had always had on campus. Zeta Tau Alpha, Theta Rho colony, was the first sorority at R-MC, with the help of the Eta Xi chapter from VPI. Eighteen women were accepted as pledges, but the group never reached the minimum number for activation. Phi Mu became the first initiated sorority in 1982.

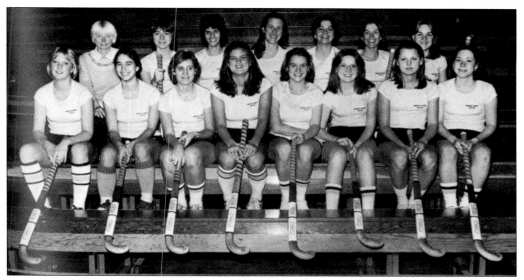

FIELD HOCKEY TEAM, 1978. Rachel Anderson came in 1972 to be an instructor in physical education. Women's teams were formed for tennis (first season, 1973), volleyball (1977), and basketball (1978). Field hockey had a club year under coach Linda Schepp in 1978 and would compete on the varsity level the next year.

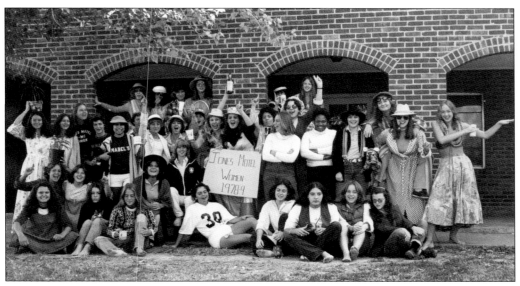

JONES MOTEL WOMEN, 1978–1979. Jones Dormitory was built in 1957 and named for professor of Greek Thomas Jones. One of the famed motel dorms, Jones was for women. Being primarily residential and with 900 students by 1978, the college needed more dormitories with different styles. However, "guests of the opposite sex [were] not permitted in students' rooms except during the hours of visitation." There was no visitation during weekdays. (Courtesy of the R-MC Marketing Office.)

BROWN FOUNTAIN PLAZA, 1976. After Alumni Gymnasium was built, the Old Gym housed classrooms, a post office, and even an art studio where Jack Witt modeled his statue of "Bojangles" Robinson for the city of Richmond. Through the years, its walls and roof continued to be used as a scoreboard and protest sign by the students. It was demolished in 1976, along with the Campus Exchange, and Brown Fountain Plaza became the new center of the campus. No longer focused on the town of Ashland or the railroad tracks, the college turned away from the Old Campus and focused on the new. Once graduation ceremonies moved to Fountain Plaza in 2007, the shift was complete. Clockwise from the bottom left are Conrad, Brown Campus Center, Walter Hines Page Library, Fox Hall, Blackwell Auditorium, Peele Hall, and Mary Branch.

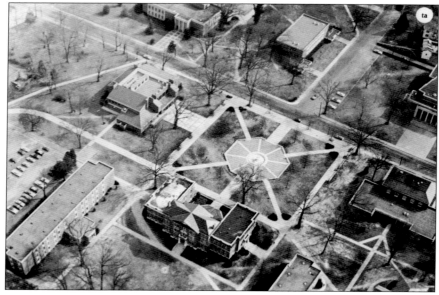

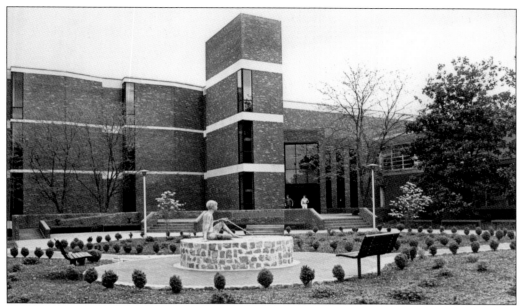

COPLEY SCIENCE BUILDING, 1984. Although the new science building was constructed in 1972, this photograph dates from the 1984 installation of the bronze sundial sculpture by Jack Witt. The boy holds a stick for the gnomon, and the base shows Virginia flora and fauna and maps of the campus. In 1983, the building was named for Dr. W. Henry Copley, class of 1934, and the sundial honors trustee Harriet Fitzgerald. (Courtesy of the R-MC Marketing Office.)

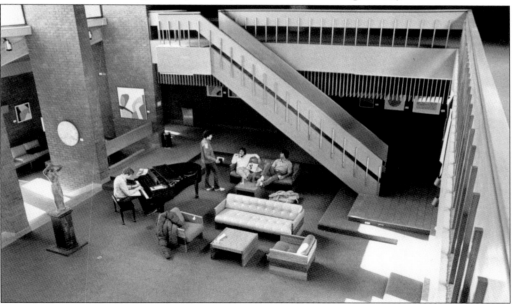

BROWN CAMPUS CENTER, 1978. Built in 1974 and named for donor Frank Brown, the new student center replaced the Campus Exchange. With a sunken "living room" and an upstairs art gallery, the center became the place for students to meet with administration. Today the Office of Student Life keeps the facility at the center of cocurricular life, with Macon Coffee, the bookstore, student life offices, and space for commuter students. (Courtesy of the R-MC Marketing Office.)

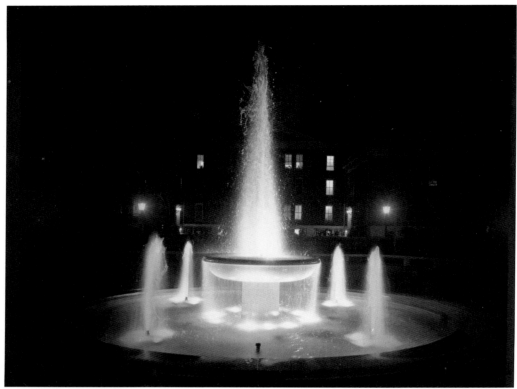

BROWN FOUNTAIN PLAZA, 1970 AND 1976. Built in 1968 and named for Frank E. Brown, a trustee from 1955 until 1976, the fountain once had colored lights, but white ones have since replaced them. At night, the fountain lights shine against dormitory windows. Occasionally, the fountain also has had soap suds, and it was a favorite prop for student yearbook poses. The plaza itself allows a place for college picnic lunches, activity fairs, protests, and other student gatherings. Mary Branch Dormitory, built 60 years earlier, provides a scenic backdrop for the fountain.

CHEMISTRY DEPARTMENT, 2009. One fountain tradition is a photograph of graduating chemistry seniors and their faculty. Commencement is held on the steps of Mary Branch Dormitory, and students and faculty process around the fountain to take their seats for the ceremony. The fountain is turned off during the ceremony itself but turned back on in full force for the recessional. The Fountain Plaza also draws Ashland residents, and it is a prime location for buying strawberries at the Strawberry Faire each June and for watching the Ashland Old-Time Holiday Parade each November.

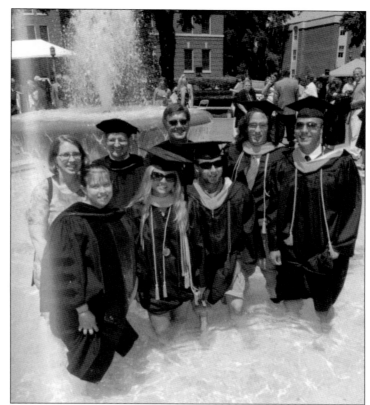

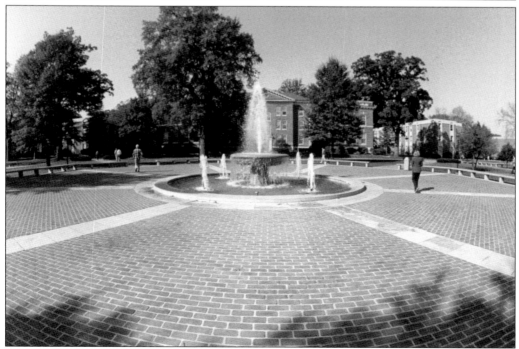

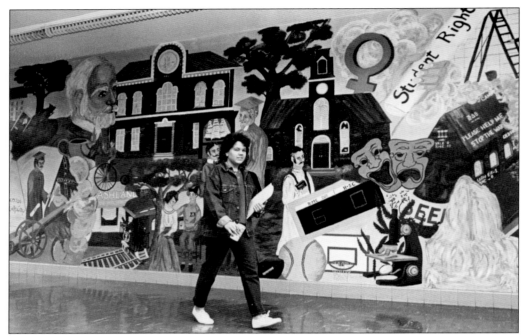

MURAL, FOX HALL, 1976. Painted as the work of Mural Colloquy 022, a college course taught by Prof. Tom Porter, the mural covers the history of Randolph-Macon College from (left to right) the early days in Boydton, the Civil War, the move to Ashland, the building of Wash-Frank Hall and Old Chapel, the coming of women, and the destruction of Old Gym to the rainbow of hope for the future.

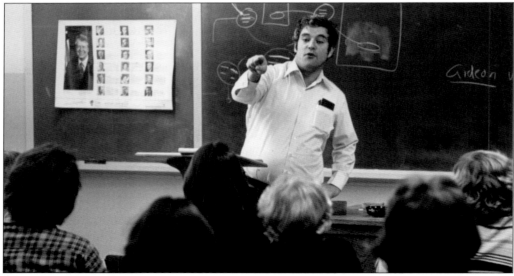

BRUCE M. UNGER, PROFESSOR OF POLITICAL SCIENCE, 1978. Fox Hall still houses classroom and faculty offices, and while Jimmy Carter is no longer the U.S. president, teaching remains the central focus of the college. Spring Convocation honors recipients of the Thomas Branch Awards for Excellence in Teaching, the United Methodist Church Exemplary Teaching Award, and the Samuel Nelson Gray Distinguished Professor Award.

ESTES DINING HALL, 1982. Besides increasing the endowment, President Payne added many buildings to the campus. Above, Payne (second from left) accepts a check from James Jordan in memory of Troy Leadbetter. Payne also doubled the size of the (McGraw-) Page Library, built four dormitories, and bought eight residences plus the old Catholic church, St. Ann's. Don Reid, standing at the far right, served as treasurer for 14 years. (Courtesy of the R-MC Marketing Office.)

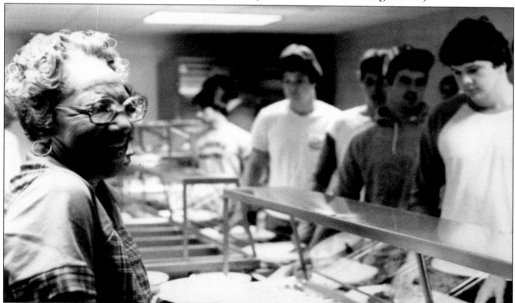

MISS EMILY, AUGUST 1981. Photographed on the opening day of the new Estes Dining Hall, the beloved Emily Goings continued to serve students. Goings worked for many years at the college, one of the many workers in the Office of Operations and Physical Plant who take care of faculty and students. Estes Dining Hall was named for C. Edwin Estes, president of Great Coastal Express.

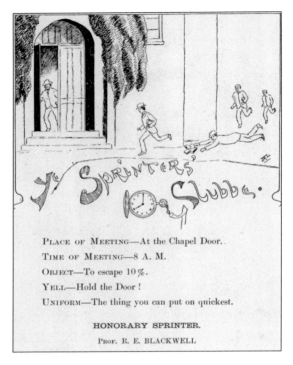

PLACE OF MEETING—At the Chapel Door.
TIME OF MEETING—8 A. M.
OBJECT—To escape 10%.
YELL—Hold the Door!
UNIFORM—The thing you can put on quickest.

HONORARY SPRINTER.
PROF. R. E. BLACKWELL

YE SPRINTERS' CLUBBE, 1901. One club recognized the race to get to chapel by 8:00 a.m. Students and faculty were required to attend, and it should be noted that an honorary sprinter was Professor Blackwell. Perhaps he did better when he was President Blackwell. Sometimes the bell ringer kindly delayed until the sprinters made it through the door. The bell ringing continued through the day to mark the change of classes.

"UNCLE BOB," 1939. The chapel bell was hung in May 1904, and bell ringers included "Judge" Crawley and "Uncle Bob." The bell was the object of many student pranks, such as cutting the bell rope or stealing the clapper. It was rung by the freshmen after an athletic victory and all night for a championship. As pictured in the 1939 yearbook, Uncle Bob retired in 1939 after 30 years of service, "a faithful alumnus of Randolph-Macon."

FRESHMEN WITH BELL CART, 1967. In 1954, the bell was removed from the chapel tower for reasons of safety and put into storage. In 1966, students found, stole, and mounted the bell on a cart, and it resumed its place at athletic events. In 1972, the bell was mounted on top of Blackwell Auditorium but was returned to Old Chapel during its restoration in 2002.

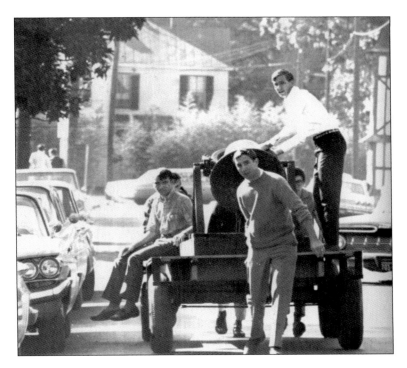

HENRY LEE TALIAFERRO, 1972. Many staff made the yearbook through the years, and the college has always needed the care of custodians. Taliaferro worked for more than 30 years and was as beloved as "Judge" or "Uncle Bob" (also shown on opposite page). In 1988, the Emerson Physical Plant Building was named for six members of the Emerson family who had worked a total of 119 years at the college, including Lawrence Emerson Sr. and Larry Jr.

OLD GRADS, MAY 1982. The class of 1932 joined the "Old Grads" on the occasion of their 50th reunion. Fifty-year class reunions had long been held at R-MC, but beginning in 1979 the classes were welcomed to the Old Grads, now officially the Boydton Society. These distinguished alumni process and are honored at commencement each spring. Front and center is Dorothy Jones. (Courtesy of the R-MC Alumni Office.)

JACKETETTES FALL BEFORE ATTACK OF HIGH SCHOOL ALUMNAE

Jones, Ellis, Jeter, Bryant, Stone Outstanding Players— Game Slow

Playing boys style basketball, a fighting Jacketette quint went down before superior Ashland High School Alumnae to the tune of 16 to 11, last Monday night.

The game was slow and marked by roughness, until the last quarter. It was not until after three minutes of play that either team scored. It was then that Jones dropped in one from the foul stripe and on the next play looped the basket for a two pointer. Th Jacketettes allowed the Alumna only one free toss during the first quarter, the quarter ending 5 to 1 with the Coeds in the lead. The Jacketettes continued the same style playing the second quarter. The Alumnae still were unable to overcome the Jacketettes, the half ending 8 to 5 in favor of the Coeds.

JACKETETTES, 1931. Dorothy Gardner Jones was an Ashland town girl, who, long before R-MC went coed, graduated with a major in Latin and Greek. In order to meet the college physical education requirement, Jones started a women's basketball team that had to play by men's rules. After earning a doctorate, Jones taught sociology at Winthrop College for 35 years.

JAY PACE, 1969. J. Malcolm "Jay" Pace III, class of 1967, worked at the college as director of information services and editor of the alumni bulletin from 1968 to 1972, but left to become editor and publisher of the *Herald-Progress* newspaper. Through his activities, such as musical director for the variety show, Pace kept a close connection between town and gown. In 2008, McGraw-Page Library acquired the newspaper's photographic morgue.

CAMPUS BOOKSTORE, 1994. Relocated from the Campus Exchange to the basement of Mary Branch, then moved again to the new Brown Campus Center, the college bookstore remains a popular spot for students to buy textbooks and R-MC souvenirs. Barclay DuPriest (second from right) took over from Kathryn Stephens, and the bookstore draws alumni for the latest news and coeds for the latest Vera Bradley. (Courtesy of the R-MC Marketing Office.)

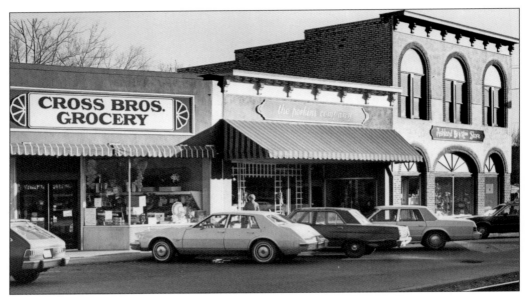

DOWNTOWN ASHLAND, 1980s. Storefronts downtown have changed hands and wares many times, but Cross Brothers Grocery, started in 1912, remains an integral part of Ashland life. Barnes Drug Store, Ashland Theatre, Meade and Company, and Koon's Barber Shop advertised in the *Yellow Jacket Yearbook* and *Fishtales*. Today faculty and students are still able to walk between campus and downtown for coffee, errands, and lunch. (Courtesy of the R-MC Marketing Office.)

CAMPTOWN RACES. Beginning in 1953 and for many years after, horse racing was revived about 3 miles north of Ashland, on Manheim Farm. On the second Saturday in May, R-MC students were among the 20,000 spectators that watched seven races of quarter horses, thoroughbreds, and a hunter's relay. In later years, the student celebrations continued (without horses) on campus and were later transformed into Earth Day celebrations.

STRAWBERRY FAIRE, 1995. Beginning in June 1982, the town of Ashland has held Strawberry Faire on the college campus. The Ashland Berry Farm began the effort to bring fresh strawberries to the attention of the Ashland community with crafts booths, live entertainment, public service booths, and Miss Strawberry contests. Here set out in front of the Old Chapel, the Strawberry Faire has grown to cover much more of the campus.

MAYOR "DICK" GILLIS, 1988. Since 1983, the Ashland Musical Variety Show is a biennial event with participants from the Ashland and college communities. The show concludes with a rousing chorus of "Ashland, Ashland, Center of the Universe." Gillis, class of 1940 and mayor from 1977 to 1989, fought to regain regular Amtrak passenger service to Ashland in 1982. Full passenger service still brings students to campus.

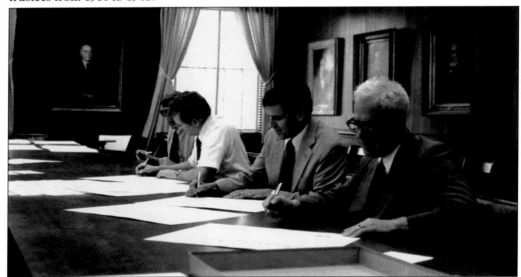

DIPLOMA, 1892. In the college archives is the diploma of Homer Henkel Sherman, dated June 17, 1892, and signed by the officers and faculty of the college. Among the trustees are Richard Irby and John Granbery; among the faculty, Blackwell, Smithey, Kern, Wightman, and Pres. William W. Smith. The diploma is for the baccalaureate in liberal arts. Sherman served on the board of trustees from 1914 to 1948.

MULLEN BOARDROOM, EARLY 1980s. Continuing the tradition of signing diplomas are, from left to right, Ira Andrews, dean of men; Elton Hendricks, dean of the college; Ladell Payne, president; and Don Reid, treasurer. Pens are out for the signing, as the officers sit at the board table, surrounded by the portraits of past presidents.

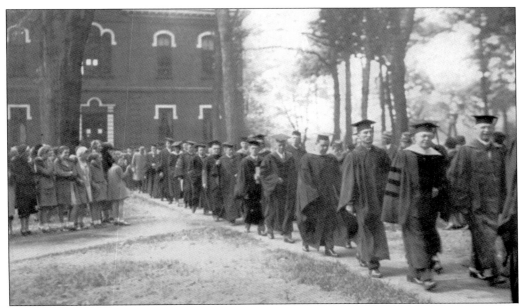

ACADEMIC PROCESSIONS, OCTOBER 24, 1930, AND 1961. On the occasion of the 100th birthday of the college (above), students, alumni, delegates, and faculty in their regalia and by order of seniority march from the Administration Building (Wash-Frank Hall) to the new gymnasium (Alumni Gym). Festivities that day included speeches by Virginia senator Claude Swanson, class of 1885, and Rep. Patrick Drewry, class of 1896. Academic processions continued, such as the one below from 1961, entering Blackwell Auditorium for baccalaureate services. The colors, bars, and hoods of faculty regalia indicate their disciplines, degrees, and alma maters.

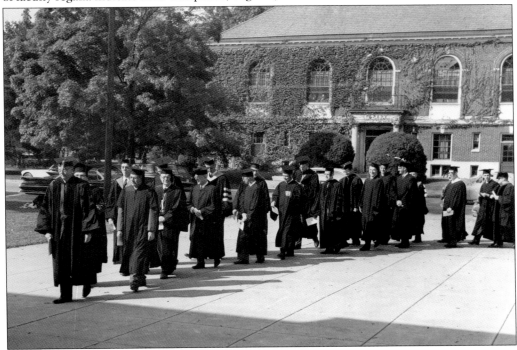

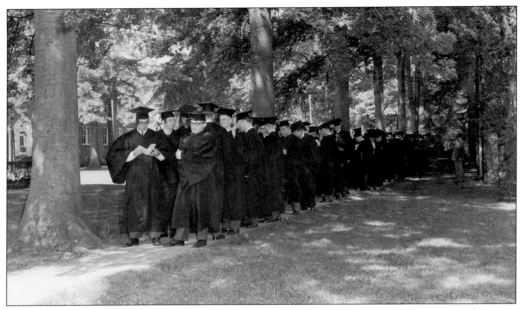

STUDENT PROCESSION, 1961. Passing by the side of the Old Chapel, on the way to baccalaureate exercises in Blackwell Auditorium, students follow the path of the faculty under the oaks and maples of the campus. Today, on their way to Fountain Plaza for commencement exercises, graduates walk over the Janet Harvey Trivette Alumni Walkway, a sidewalk composed of bricks inscribed with graduates' names by class year.

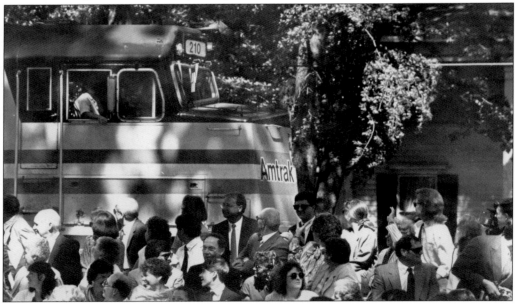

COMMENCEMENT, 1989. For many years, commencement was held in the Old Campus. The ceremony was always halted as the Amtrak train stopped at the Ashland station for its passengers. With a friendly call of the horn, the conductor would wave and pull out of the station. Commencement speakers were usually warned that their speeches were too long if more than three trains went by during their talk.

GHOST OF A FACULTY HOUSE, 1951. As today, students walk along the south side of Fox Hall towards Mary Branch Dormitory, across Henry Street. But unlike today, there is a lovely white frame house instead of Fountain Plaza. The home is one of the faculty houses, four of which are on the 1965 campus map. Through the years, this one had housed Professors Blackwell (English), Bowen (Latin), and Updike (chemistry).

GHOST OF OLD GYM AND CAMPUS EXCHANGE, 1974. Pres. Luther White walks alongside Conrad Dormitory from Mary Branch Dormitory. On the left are the small, brick Campus Exchange and the Old Gym, with its protest graffiti—"Help Me Stop the War!" The Old Gym, perhaps the oldest gym in the South, had stood for 87 years, but both buildings were torn down in 1974.

GHOST OF PETTYJOHN, 1975. Torn down in 1976, Pettyjohn Science Hall stood for 86 years on Old Campus, alongside the railroad tracks. With the expanded student numbers, cottages gave way to larger dormitories. In 1970, Conrad Dormitory was built, and where this student walks, Conrad sits in the sunshine, and the ghost of Pettyjohn lies in the shade.

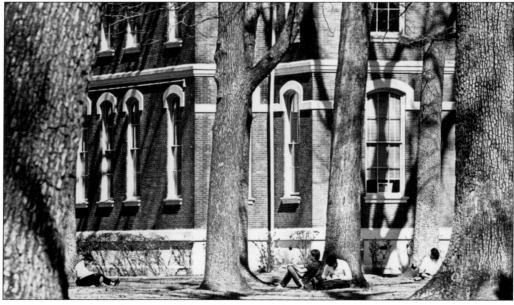

OAKS AND MAPLES. Students sit and sketch by Pace Hall, in the shade of the trees of the alma mater. The college alma mater is sung to a tune written in 1870 by two Cornell students: "Bowered midst its oaks and maples / Beautiful to view / Stands our noble Alma mater / Randolph-Macon true. Lift the chorus / Speed it onward / Ne'er let praises fail! / Hail to thee, our Alma Mater—Randolph-Macon, Hail!"

126

BIBLIOGRAPHY

Dolan, Thomas W. "Origins of the First Campus of Randolph-Macon College: An Architectural Note." *Virginia Magazine of History and Biography* 93 (October 1985): 427–434.

Garland, S. M., ed. *Randolph-Macon Monthly: Semi-Centennial Edition*. Ashland, VA: J. B. Savage, 1882.

Irby, Richard. *History of Randolph-Macon College, Virginia*. Richmond, VA: Whittet and Shepperson, 1890.

Scanlon, James Edward. *Randolph-Macon College: A Southern History, 1825–1967*. Charlottesville, VA: University Press of Virginia, 1983.

———. *Randolph-Macon College: Traditions and New Directions, 1967–2005*. Forthcoming.

www.arcadiapublishing.com

Discover books about the town where you grew up, the cities where your friends and families live, the town where your parents met, or even that retirement spot you've been dreaming about. Our Web site provides history lovers with exclusive deals, advanced notification about new titles, e-mail alerts of author events, and much more.

MADE IN THE USA

Arcadia Publishing, the leading local history publisher in the United States, is committed to making history accessible and meaningful through publishing books that celebrate and preserve the heritage of America's people and places. Consistent with our mission to preserve history on a local level, this book was printed in South Carolina on American-made paper and manufactured entirely in the United States.

This book carries the accredited Forest Stewardship Council (FSC) label and is printed on 100 percent FSC-certified paper. Products carrying the FSC label are independently certified to assure consumers that they come from forests that are managed to meet the social, economic, and ecological needs of present and future generations.

FSC

Mixed Sources
Product group from well-managed forests and other controlled sources

Cert no. SW-COC-001530
www.fsc.org
© 1996 Forest Stewardship Council

Find Your Place in History.